IMAGES
of America

HAMPTON
NATIONAL
HISTORIC SITE

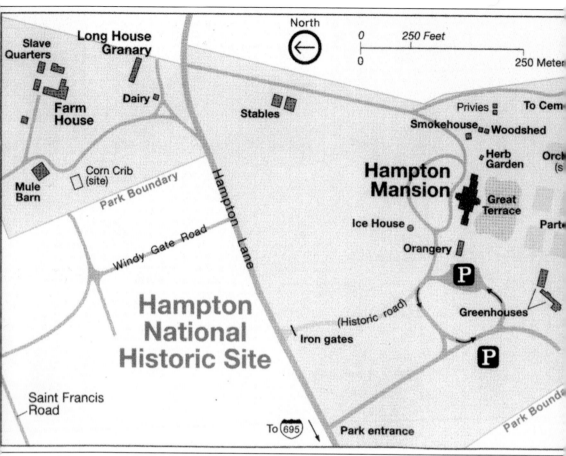

This site map shows the extent of Hampton National Historic Site today, with the home farm property on the north side of Hampton Lane and the original portion including the mansion and its surrounding acreage on the south side of Hampton Lane. The park is located north of the city of Baltimore just north of I-695 in Towson, Maryland.

ON THE COVER: Taken by Julian White (1853–1923), this *c.* 1890 photograph highlights the southern facade of the mansion. The inscription on the back indicates the people seen are "Lena, Stew and Baby Jule in carriage." Lena is Selena Devlin, a beloved nursemaid/servant and one of only two non-family members buried in the Hampton cemetery. "Stew" is David Stewart Ridgely (1884–1978), and Baby Jule is Julian Ridgely (1887–1939). Note the overgrown wisteria covering much of the portico and the striped window awnings. (Courtesy of Hampton National Historic Site/National Park Service.)

IMAGES
of America

HAMPTON
NATIONAL
HISTORIC SITE

Ann Milkovich McKee on behalf of
Hampton National Historic Site

ARCADIA
PUBLISHING

Copyright © 2007 by Ann Milkovich McKee on behalf of Hampton National Historic Site
ISBN 978-0-7385-4418-2

Published by Arcadia Publishing
Charleston, South Carolina

Printed in the United States of America

Library of Congress Catalog Card Number: 2007922280

For all general information contact Arcadia Publishing at:
Telephone 843-853-2070
Fax 843-853-0044
E-mail sales@arcadiapublishing.com
For customer service and orders:
Toll-Free 1-888-313-2665

Visit us on the Internet at www.arcadiapublishing.com

To my husband, Gary, who shares my love of Hampton;
My son, Joseph, may history fascinate you as much as it does me;
And my ever-faithful companion, Katiedog . . . yes, now we can go play!

CONTENTS

ACKNOWLEDGMENTS

Thanks to all the staff at Hampton National Historic Site/National Park Service for your support and encouragement and especially Laurie Coughlan (site superintendent), Gay Vietzke (general superintendent), Julia Lehnert (archivist), and Gregory Weidman (furnishings project coordinator). I want to recognize two former Hampton employees, Lynne Dakin Hastings (curator) and Debra Sturm (chief ranger, interpretation), for all their hard work in creating this project opportunity and entrusting me with it. Finally, I owe a very special thanks to Debbie Patterson, registrar at Hampton, for all her amazing assistance in choosing just the right images and preparing them for use as well as her feedback on the text. Her passion for Hampton and knowledge of its people and visual collections is incredible. I couldn't have done this without her!

It was truly an incredible experience and honor to work with such a rich historic resource collection as exists at Hampton National Historic Site/National Park Service. As a result, the majority of the images for this book are taken from these collections and are only individually marked when they are from a different source. My thanks to the National Gallery of Art and to Jennifer Bodine, daughter of Baltimore photographer A. Aubrey Bodine, for allowing me to use images from their collections and to Sally Sims Stokes for the use of pictures taken as part of Hampton's National Register of Historic Places nomination.

INTRODUCTION

Hampton National Historic Site (NHS), designated by the secretary of the interior on June 22, 1948, protects the remnants of a once-vast agricultural, industrial, and mercantile conglomerate of over 25,000 acres, one of the richest and best-preserved American estates. Recognition of the architectural importance of Hampton mansion (1783–1790) meant that this site was the first property selected to be a national park for its architectural significance. Today Hampton NHS preserves two integrated pieces of the larger historical landscape, the mansion with its gardens and many dependencies and the home farm, each retaining a diverse group of resources. Hampton's story highlights the Ridgely family, who owned portions of the land from 1745 until the last parcel was transferred to the National Park Service in 1978, exemplifying the hardworking, multitalented Americans who with determination built their American dream; the decline of the Ridgely empire due to the exigencies of history; and the lives of hundreds of persons, many enslaved, who supported this endeavor. The wealth and stature of Hampton in the fashionable world of its times is directly reflected in the designed buildings, landscapes, and collections extant at Hampton.

Hampton's combination of agricultural and industrial enterprises, complemented by foreign and domestic mercantile endeavors, provided wealth to the Ridgely family that lasted for two centuries. Major phases of U.S. history are brought to life by studying the occupancy of seven generations of this upper-class family and the large number of slaves, indentured servants, and paid laborers/servants that supported them, spanning the period from before the American Revolution to after World War II. Portions of American labor history in the 18th century can be extensively documented through Hampton, with its predominant use of indentured servants (along with British prisoners of war for several years) at the ironworks, mills, quarries, and farms supplemented by some African American slaves. By 1800, the temporary nature of indentured servitude was gradually supplanted by more and more enslaved African Americans who would live and work at Hampton for generations, along with the participation of free artisans, professional gardeners, a French chef, English governesses, and other immigrant labor. Approximately 350 slaves resided on the estate and other Ridgely properties in 1825; much of this population was manumitted in 1829. From c. 1830 until 1864, when emancipation in Maryland was enacted, 61 enslaved persons were rented or purchased to support the diminished 5,000-acre estate. The living conditions and treatment of these persons differed from earlier generations of slaves, as did some of their forms of labor. Following the Civil War, the labor system changed once again; some of the emancipated slaves remained at Hampton as paid servants, other servants were hired, and farms were rented to tenants.

Northampton began as a land grant of 1,500 acres presented to Col. Henry Darnall (c. 1645–1711), a landed gentleman who was a relative of Lord Baltimore. Col. Charles Ridgely (c. 1702–1772) purchased Northampton from Colonel Darnall's heirs on April 2, 1745, for 600£. At that time, the property included "houses, outhouses, tobacco houses, barns, stables, gardens, and orchards" (Hastings, *Hampton National Historic Site*, 3).

Tobacco trading had proven very profitable to Col. Charles Ridgely, and he began to increase his land holdings. He owned over 10,000 acres by the late 1750s, including the Northampton property. In 1760, he and two sons, John and Charles, established approximately 100 acres north of Northampton as a site for a new ironworks, and they continued to acquire more land to provide raw materials for it.

The colonel gave his son, Capt. Charles Ridgely (1733–1790), approximately 2,000 acres, including the Northampton tract. Captain Ridgely served as a shipmaster and captain for James Russell and Company until 1763, when he took over management of the ironworks. He continued to expand the Ridgely empire by diversifying his business interests to include shops, mills, stone quarries, agricultural estates, racing stables, and at least one large commercial orchard. During the Revolutionary War, the Northampton ironworks was a significant source of profit for him along with buying up confiscated Loyalist properties. He also bought more ironworks in Maryland and in Pennsylvania (Hastings, *Hampton National Historic Site*, 5, 6).

After the war, in 1783, Captain Ridgely began the construction of Hampton Hall. As he and his wife, Rebecca Dorsey, had no children, he named his nephew Charles Carnan his principal heir, with the requirement that Carnan change his last name to Ridgely. Carnan agreed and became Charles Carnan Ridgely, the second master of the Hampton estate in 1790 upon the death of his uncle. His inheritance also included 12,000 acres of land and two-thirds interest in the Northampton Company.

Charles Carnan Ridgely (1760–1829) married Priscilla Dorsey (1762–1814), the youngest sister of Rebecca Dorsey, in 1782. The two couples enjoyed a close relationship, spending a great deal of time in each others' company and eventually moving into the mansion together. Charles and Priscilla's second son, John, the fourth of their 13 children, was the first child born in the mansion, in 1790.

Charles Carnan Ridgely was a dedicated public servant, serving in the military and holding several political offices, including that of governor from 1816 to 1819. He continued to acquire land, expanding his estate to 25,000 acres at its height. Governor Ridgely owned a townhouse in Baltimore, and by 1820, he was sole owner of the Northampton Company. On his agricultural estates, tobacco was phased out and replaced with wheat, corn, and other grains. He also raised beef cattle, prize hogs, and championship Thoroughbred racehorses. He was very involved with the Maryland Agricultural Society, serving as its president.

Governor Ridgely left his mark on the mansion. He deepened the east hyphen (connecting segment), allowing for the addition of a servants' stair, and continued to add interior finishes and furnishings. He further developed the landscaped setting around the mansion, including the lawns, terraces and parterres of the formal gardens, "specialized garden structures," and the addition of specimen trees. By 1800, Governor Ridgely had added running water to the gardens. An avid owner of racehorses, he added a stable by 1805 and a racing course that is no longer in existence. Many of the principal outbuildings and circulation pathways still extant date from this time period. Life at Hampton reached its apex under Governor Ridgely; he lived well and entertained lavishly; "he had the fortune that enabled him to live like a prince, and he also had the inclination" (quoted in Hastings, *Hampton National Historic Site*, 12).

Upon the death of Governor Ridgely in 1829, most of his slaves were manumitted by the terms of his will. Hampton mansion and about 4,500 acres surrounding were bequeathed to his son, John Carnan Ridgely (1790–1867), who had married the wealthy and accomplished Eliza Ridgely (1803–1867). John and Eliza continued to live well at Hampton, mostly sustained by her family fortune.

The John Ridgelys spent a great deal of time traveling abroad and thus were familiar with all the latest design trends, whether for buildings, interiors, or landscapes. Eliza Ridgely, like her father-in-law, had an innate sense of design and purchased many works of art and lavish furnishings for the mansion. They purchased items both abroad and locally in Baltimore. Today the collection includes many of Eliza's purchases, including perhaps the most important set of Baltimore painted furniture extant. The Ridgelys also added marble steps at the north portico, plumbing including

bathrooms, heating, and gas for lighting the mansion provided by their own gas works located on the property. A number of outbuildings were built or rebuilt, including an additional stable and the creation of the "farm village" with the new stone quarters surrounding the Farm House.

A renowned horticulturist, Eliza Ridgely also was instrumental in improving the gardens. She directed the conversion of one of the boxwood parterres to beds of coleus based on designs she had seen in her travels abroad. The parterres underwent a complete redesign, and classically styled marble urns were added to link the garden and mansion visually. Many of the surviving historic specimen trees were planted during this time, including the enormous cedar of Lebanon on the Great Terrace. The gardens received much public acclaim, from the invited dignitaries to the horticultural journals of the time. A fruit orchard was continued along the eastern edge of the formal garden, and two new greenhouses were constructed, along with many other garden support structures no longer standing.

Throughout the mid-19th century, the commercial and industrial interests of the Ridgelys declined, with the ironworks virtually ceasing production in 1829. Hampton thus became an agriculturally based estate with a heavy reliance on manual labor. The main workforce shifted from a combination of indentured servants and enslaved to mainly enslaved to an entirely free and thus paid workforce after the Civil War.

John Carnan Ridgely's son, Charles Ridgely (1830–1872), became the fourth master of Hampton, inheriting the estate when his father died in 1867. He only survived his father and mother by five years, dying unexpectedly of malarial fever while he and wife, Margaretta Howard (1824–1904), were abroad in Rome, Italy.

In 1872, Hampton passed to its fifth master, Capt. John Ridgely (1851–1938), although it was managed under the terms of his father's will by his mother, Margaretta Ridgely, who served as steward until her death in 1904. The estate continued to face dramatic changes in the labor force, agricultural practices, and production during the period of Reconstruction and again during the times in the 20th century of World War I, the Great Depression, and World War II. The workforce was now entirely paid either through direct wages or a tenant-farming agreement. In both cases, the revenue from the land now was shared rather than being solely the Ridgelys' and thus created an immediate negative impact on the family wealth. Agricultural practices and production began to shift with the introduction of machinery and new market patterns. While the estate no longer needed to be self-sustaining, its profitability was directly connected to the market and the expenses incurred due to machinery or weather-related losses. The workforce was also more volatile, with people coming and going based on short-term profits or losses, and some profitability was lost with the lack of continuity.

At Margaretta Ridgely's death in 1904, the estate was further divided among various heirs based on the division of property stated in Charles Ridgely's will of 1872. Capt. John Ridgely maintained the 1,000 acres that were the entailed part of the estate and included the home farm quarter. Captain Ridgely was known as a "gentleman farmer," leaving the actual farming work to overseers and tenant farmers. His resourceful wife, Helen West Stewart (1854–1929), was the author of two books, a talented artist, and mother of eight children. She also served as one of the commissioners of the Jamestown Exposition of 1907.

John Ridgely Jr. (1882–1959) was the last private owner of Hampton, inheriting the property after his father's death in 1938. After his marriage to Louise Roman Humrichouse in 1907, he built a large house at 501 Hampton Lane, but when Louise died in 1934, he moved back to Hampton mansion. In 1929, John Ridgely Jr., with the agreement of his father, established the Hampton Development Corporation and began to sell parcels of land for suburban housing developments. Even so, with the rising costs of maintaining the property and the family fortune reduced even further through taxes, John Ridgely Jr. was faced with a common dilemma of the "land rich." He remained concerned, however, about the fate of Hampton mansion, not wanting to see it demolished for continued suburban development.

As the result of an opportune meeting, David Finley, the director of the National Gallery of Art, went to Hampton in 1945 to examine Thomas Sully's great portrait of Eliza Ridgely, *The Lady*

with the Harp (1818), which the National Gallery was interested in acquiring. This painting was subsequently purchased for the National Gallery, and a portrait of Charles Carnan Ridgely (1820), also by Sully, was given by Mr. and Mrs. John Ridgely Jr. to the gallery at the same time. David Finley discussed Ridgely's concern about Hampton with a number of individuals in Washington. Finley was able to raise a great deal of interest in the preservation of the property, and after long negotiations, Hampton was sold to Avalon Foundation, which in turn donated it to the park service in 1948. In agreement with the National Park Service, the Society for Preservation of Maryland Antiquities was appointed the custodian of the property. The success of negotiations on the nationally significant landmark led these individuals to form the National Trust for Historic Preservation. Hampton was designated as a National Historic Site on June 22, 1948, and on May 2, 1949, it was opened to the public.

At that time, John Ridgely Jr. and his second wife, Jane Rodney, moved to the Farm House. A wing providing additional living space and modern conveniences was added to it in keeping with their specifications. He passed away in 1959, and Jane retained life tenancy until her death in 1978. The National Park Service then purchased the home farm from the Ridgely family heirs and assumed full management of the site.

One

THE DESIGNED LANDSCAPE AT HAMPTON

The landscapes at Hampton play an integral part in the overall design of the estate. "Physical evidence suggests that the Hampton estate was located and constructed in response to topographic and natural features" (*Cultural Landscape Report*, 33). Several examples of this include the mansion being placed on the highest plateau and being oriented to take advantage of the prevailing winds; the design of the formal gardens taking advantage of the slope by using cascading terraces; and the dairy utilizing the cooling power of a natural spring-fed stream by literally being built on top of it. Vegetation at Hampton includes both natural woodlands and exotic plantings from the late 18th century through the 20th century.

The landscape south of the mansion includes both the designed formal gardens and remnants of a household orchard to the east. Gardens and orchards were terraced, taking advantage of the sloping terrain and southern exposure for planting. The terraced formal garden, the design of which evolved over time, retains six falling terraces and some historic plantings. Today an orangery, ruins of two large greenhouses, a garden maintenance building, and the caretaker's house give visual clues to the many support structures needed for a garden of this size.

Southeast of the mansion is the walled family cemetery and its access road. The road is unpaved and after winding through remaining woodlands ends at the iron cemetery gates. The classical-style family burial vault is on an axis with these gates and is the dominant feature in the cemetery.

The north lawn retains much of its designed English landscape park form from the late 18th century. In contrast to the terraced gardens, this naturalistic design was later enhanced by elements of the picturesque movement popular in the 19th century. The north lawn also includes the two stables, the ice house, and the entrance gates, all significant historic structures.

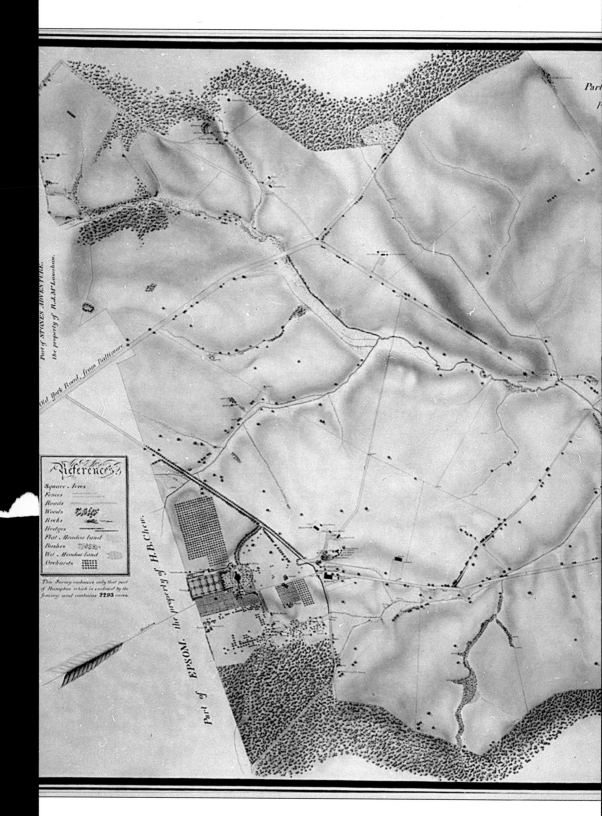

Part of

Part of STONES ADVENTURE,
the property of R.J. McLanahan.

Old York Road, from Baltimore.

References
Square Acres
Fences
Roads
Woods
Rocks
Hedges
Flat Meadow land
Bushes
Wet Meadow land
Orchards

This Survey embraces only that part
of Hampton which is enclosed by the
fencing, and contains 2295 acres.

Part of EPSOM, the property of H.B. Chew.

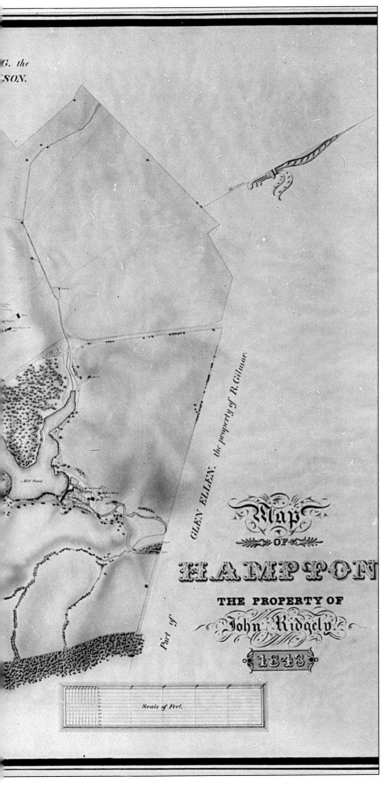

G. the
SON.

GLEN ELLEN. *the property of R.Gilmor.*

Part of

Map

OF

HAMPTON

THE PROPERTY OF

John Ridgely

1843

Scale of Feet.

John Ridgely (1790–1867) commissioned this map depicting 2,293 contiguous acres surrounding Hampton in 1843. It was drawn by Joshua Barney, a civil engineer, surveyor, and cartographer who would go on to work for the Army Corp of Engineers, creating a number of surveys for such uses as railroad routes. The map of Hampton provides an incredible historical record, as it indicates the buildings and structures on the site at the time, identifying many of them, some of which no longer stand The topography is shown through shading, and a detailed reference key defines the markings for differing types of vegetation, fencing, rocks, and roads. Adjacent property owners and roads are also indicated. Realizing that the mansion and home farm are located in a small area of the lower left corner gives one a sense of the vast property that was once a part of Hampton.

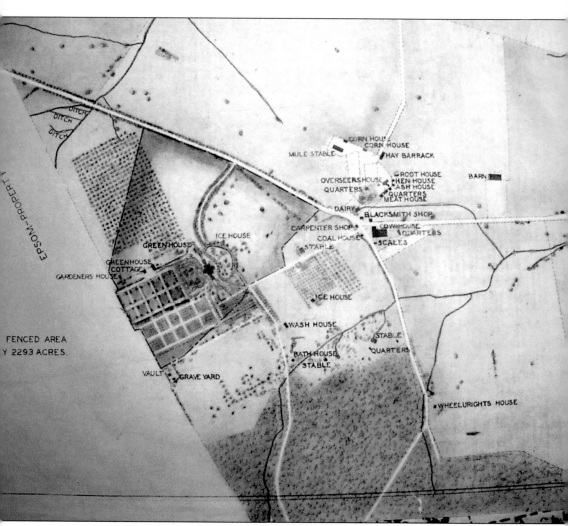

This is a detail from the Barney map on the previous page showing the mansion and home farm. On the mansion side, the formal terraced garden is indicated, as are large orchards on either side of it. The footprint of the mansion is delineated, along with several surviving outbuildings surrounding it, including the ice house, a stable, a greenhouse, and the gardener's house. The cemetery with its vault is labeled. Additional buildings, no longer extant, such as quarters, a washhouse, a bathhouse, and an additional ice house are also indicated. Clustered at the bend in Hampton Lane are more utilitarian buildings connected with the home farm. Buildings found on this part of the map that still exist today include the mule barn, the overseer's house, and the dairy. One of the most impressive buildings shown is the huge cow house (now demolished).

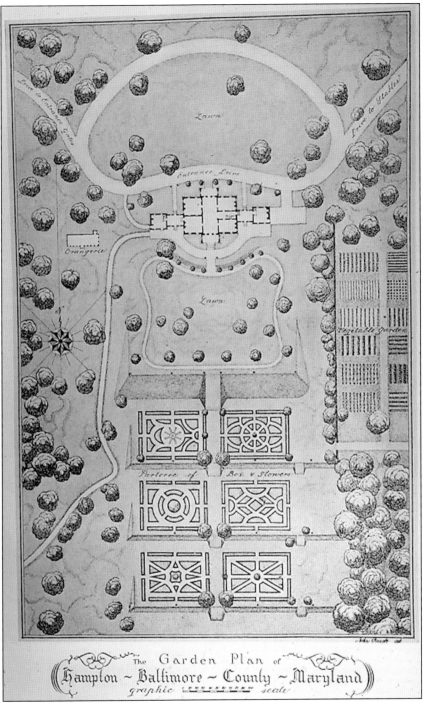

The Garden Plan of
Hampton ~ Baltimore ~ County ~ Maryland
graphic scale

This illustration drawn in 1902 by Laurence Hall Fowler, a prominent Baltimore architect, is important for its documentation of the parterre planting patterns. Along the right side of the image, the edges of a large walled vegetable garden and one of the fruit orchards are shown. Interestingly, while plans of the mansion and the orangery are shown, none of the other existing outbuildings adjacent are. (Courtesy of *Great Georgian Houses of America*, vol. 1, 1933.)

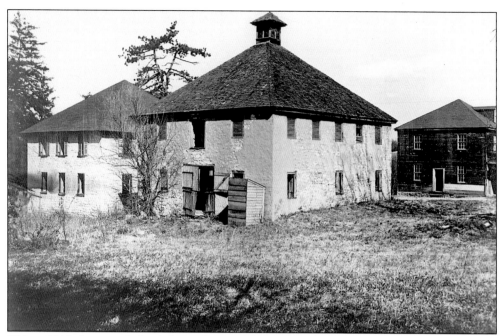

This c. 1940 photograph (top) shows the two Thoroughbred stables adjacent to the north lawn with the carriage house in the background. Stable No. 1, in the foreground, was built c. 1798–1805, and Stable No. 2 was built c. 1855. Both are stone structures, though Stable No. 1 is of rubble stone that was originally stuccoed and scored to match the mansion. The first story of Stable No. 1 was divided into stall boxes (lower photograph, c. 1935) and a tack room, while Stable No. 2 was just divided into stall boxes. Both had unfinished loft spaces. The original cupolas were removed because of deteriorated conditions.

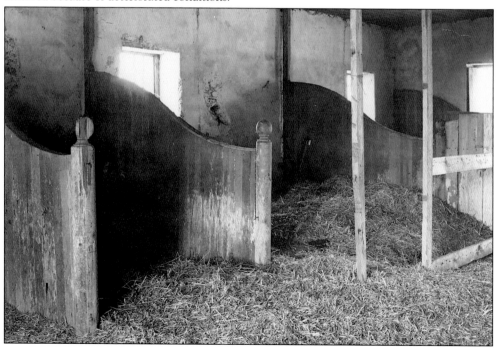

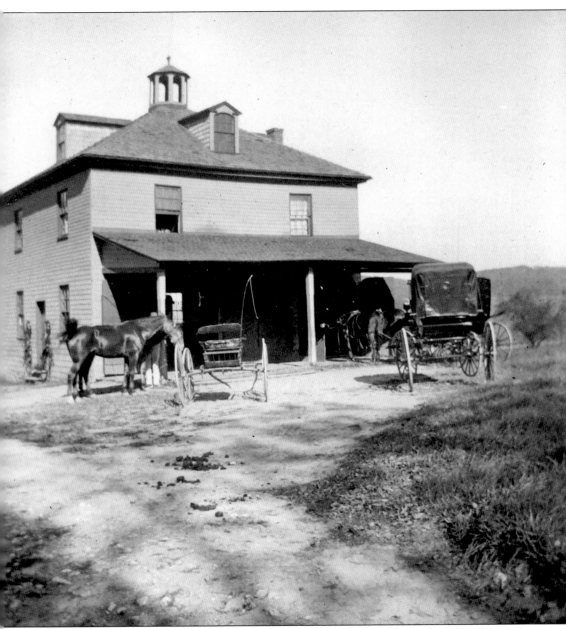

The carriage house, no longer extant, stood on the east side of the East Road, also referred to as Stable Drive, and served as the main carriage house for the Ridgely family and their guests. Seen here c. 1897, it was a wooden two-and-a-half-story structure with a pyramidal roof and cupola complementing the stables. A small buggy and several larger carriages with corresponding horses can be seen by the porch.

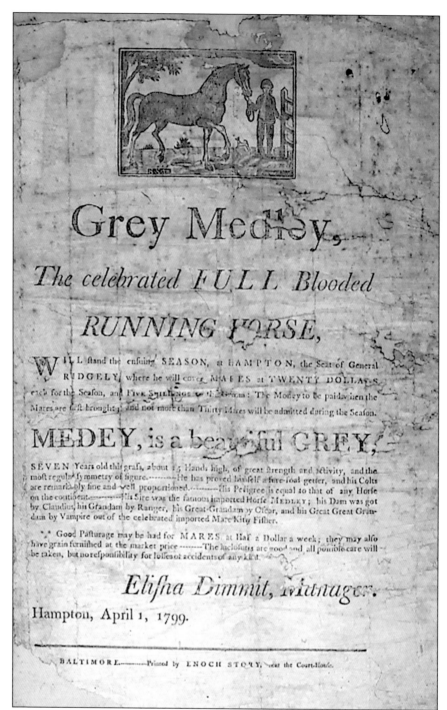

A leaflet dated April 1, 1799, proclaims the availability of General Ridgely's racing stallion Grey Medley for stud services. The fees are listed as "20 pounds for the season and five shillings for the groom." For visiting mares, "pasturage may be had for half a dollar a week with grain furnished at market price." The leaflet extols the good lineage of Grey Medley, his proven stud record, and his fine physique. (Courtesy of private owner.)

This 50-guinea cup was awarded to Charles Carnan Ridgely for his winning racehorse, Post Boy, at the Washington City Jockey Club in the fall of 1805. The trophy is ornately engraved, including an illustration of a horse and jockey and the name Post Boy. It can be disassembled into three parts: a small cap with horse-head finial, a domed lid that reverses to a mixing or punch bowl, and the base, which forms a double-handled cup.

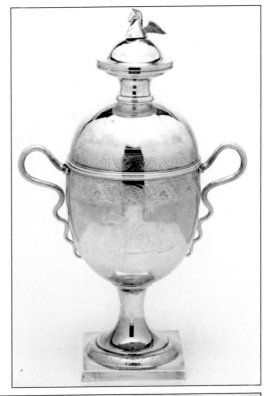

This document records a proposed wager between Charles Carnan Ridgely and Myles Seldon for a race to be run by the Ridgely-owned horse Post Boy and Burwell Wilkes's horse Potomac. The race was supposed to take place in October 1809 at the Washington City Jockey Club Race Course; the wager proposed on January 10, 1809, was for the extraordinary sum of $10,000. The outcome of the race is unknown.

Memorandum of a proposed Bet made between Henry
Thompson on behalf of Gen.ᵉ Chaˢ Ridgely of Baltimore &
Cob Myles Seldon of Richmond,

Henry Thompson for said Ridgely bets Cob Myles
Seldon Ten Thousand Dollars that Gen.ᵉ Ridgely's Horse
Post Boy can beat Mr Wilkes' Horse Potomac the Four
Mile Heats on the second Monday in October next, over
the Washington City Jockey Club Race Course; to Run
agreeably to the Rules of said Club—

Cob Seldon is allow'd fourteen days to
accept or reject the above Bet

Richmond

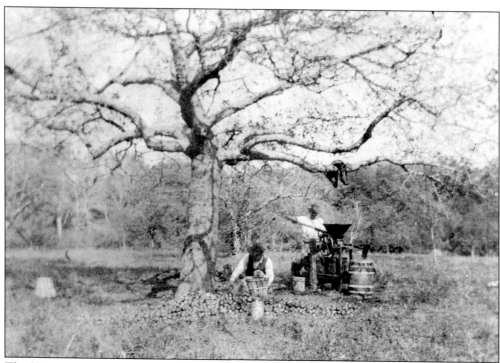

The Hampton estate maintained a number of fruit orchards, some for commercial endeavors and others for use on the property. Here are *c.* 1900 images of two men working under a large tree making cider in a handpress. A pile of apples can be seen in front of the tree, along with scattered bushel baskets. Large barrels are visible, and in the top photograph, one is being filled with cider from the press.

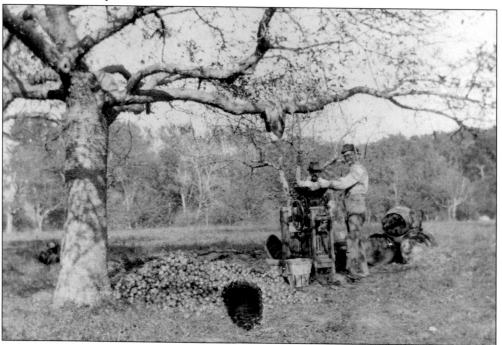

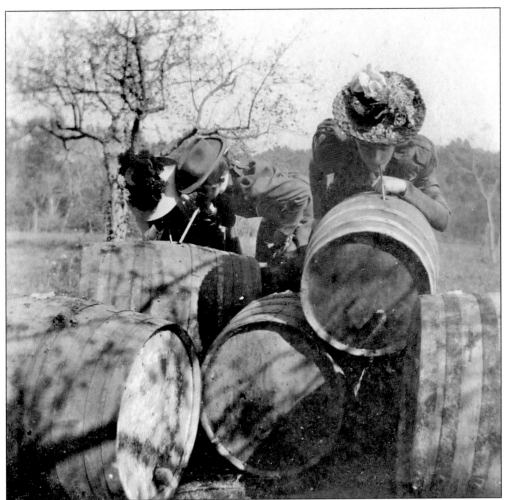

This *c.* 1900 photograph catches three young women sipping freshly made cider directly from a barrel. Inscriptions with the photograph indicate that at least two are daughters of John Ridgely, and a similar photograph identifies one as Margaret.

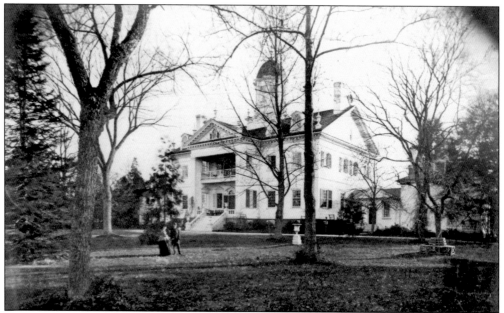

The landscape on the north side of the mansion was designed to give the impression of a naturalistic setting, mainly lawn surrounded by groupings of several species of trees, in contrast to the terraced gardens. An unidentified couple, possibly Capt. John and Helen Ridgely, enjoy a stroll on the north lawn in this c. 1875 photograph. Note the wooden trellises leaning against the mansion and the seat around the tree trunk.

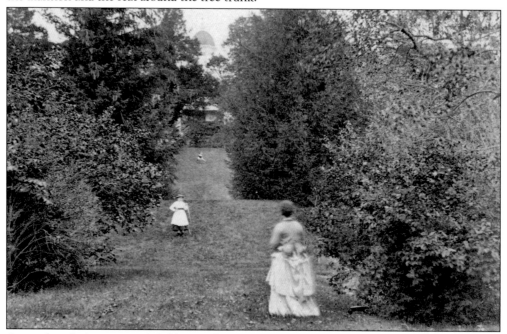

An unidentified woman and child are walking up the ramping central path of the terraced garden in this c. 1875 image. The great height change between terraces can be truly appreciated when seen in human scale. The distances are further accentuated by the rows of trees on either side. The south facade of the mansion is barely visible in the distance.

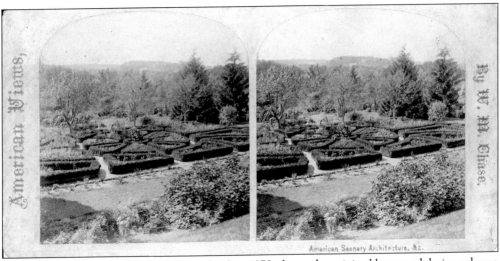

This stereograph view of Parterre No. 1 (top), *c.* 1872, shows the original boxwood design scheme with gravel paths dating from 1795 to 1810. This represented the second major landscaping campaign in the gardens, with the original plantings just lawn to prevent erosion of the terraces. The third phase began *c.* 1840, when Eliza Ridgely altered all but Parterre No. 1 (northeast corner) to incorporate the more up-to-date style of lush planting beds of annuals set off by exotic plant materials and grass paths. This later style can be seen in the lower image, *c.* 1870–1875, looking out over the gardens from the Great Terrace path with the greenhouses in the background. Stereographs were a popular form of entertainment as well as a teaching tool from their development in the 1840s until the 1920s.

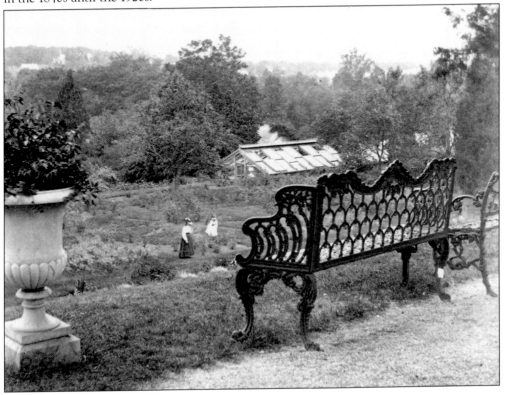

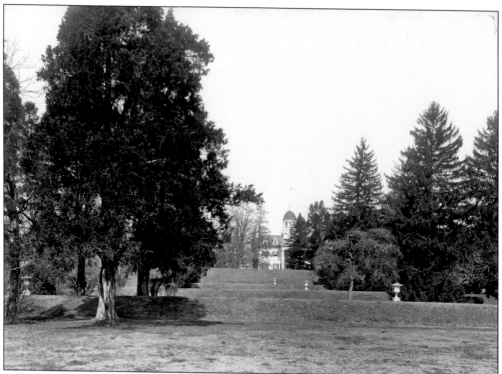

From at the bottom of the terrace gardens looking up toward the mansion, around 1908, this image captures the stepped profile of the terraces. The change in landscaping, especially the absence of large-scale vegetation in the parterres, is quite evident. Most of the surrounding trees seen in older photographs still survive.

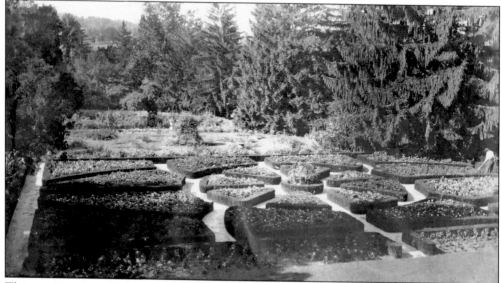

This c. 1900 photograph shows half of the terrace garden parterres, Parterres No. 1, 3, and 5. Parterre No. 3 and Parterre No. 5 are planted with flower beds in a simplified geometric pattern with a specimen tree in the center. Parterre No. 1 remains highly manicured in its historic geometric design created with boxwood shrubs surrounding flower bed and gravel paths.

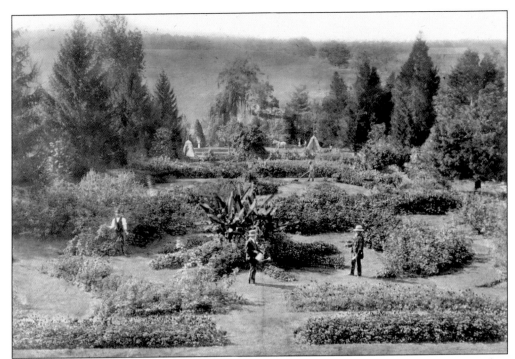

These two photographs taken in 1879 give an idea of the large amount of labor required to maintain this size of garden. While the head gardener was a well-paid employee of the Ridgelys during the early 19th century, the bulk of the labor was done by slaves. After the Civil War, the gardens were tended by a paid and much-reduced gardening staff. These images show gardeners at work with hand-drawn equipment in the background.

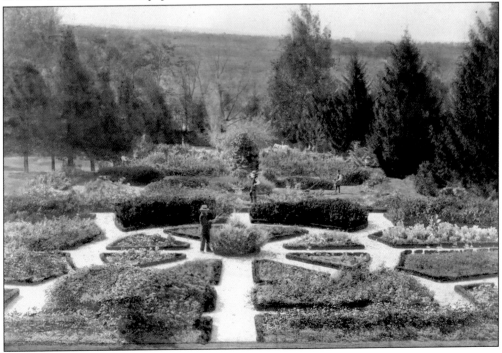

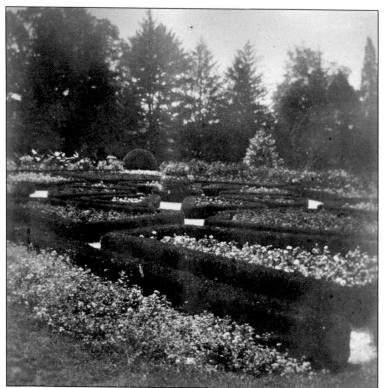

This *c.* 1897 close-up view of Parterre No. 1 shows the combination planting of boxwoods and annuals found in the garden during this time period. It was still a labor-intensive venture that would see decreasing amounts of money available for its support, even with the cost-saving measures to reduce hand labor developed by Helen Stewart Ridgely.

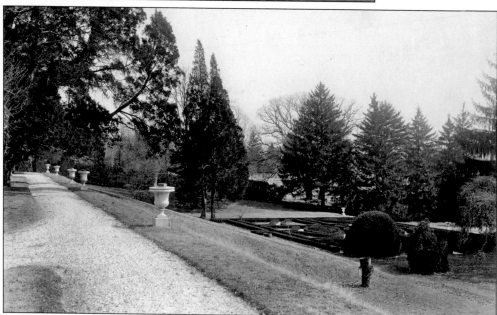

Looking east around 1908 while standing on the historic Great Terrace path, one can see the large elevation change to the first terrace, which gives the garden its impressive terrain. The transition is made with a large, grass-covered ramp that leads to a central path extending the length of the garden. One of the many marble urns purchased by Eliza Ridgely in the mid-19th century for use in the gardens and around the mansion can be seen along the path's edge.

This view is also taken on the Great Terrace path but looking westward, with the ramping path down to the first terrace in the background. Taken around 1897, this photograph shows one of the marble urns planters placed on the garden side of the path. The garden was more than a showplace, with the Ridgely family using it for enjoyment, as the placement of rustic lawn furniture suggests.

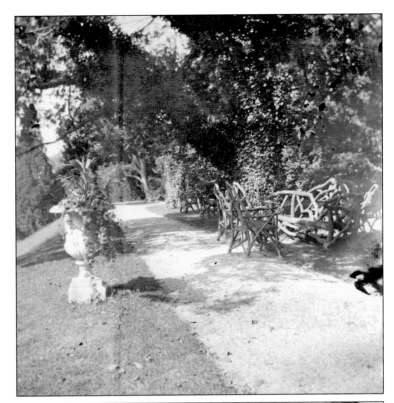

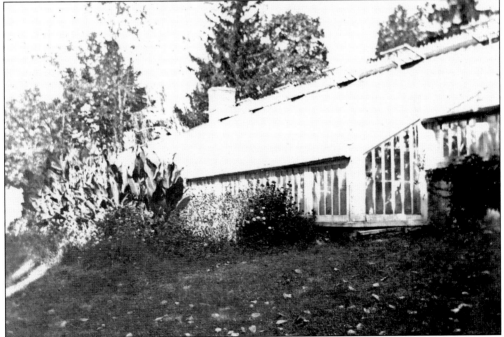

The greenhouses played a large role in the success of the landscapes at Hampton over its history, both for growing cut flowers and for starting bedding plants. This c. 1897 photograph shows one of the greenhouses with several open skylights.

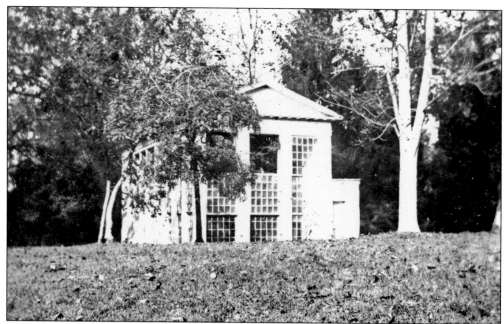

The original orangery, shown around 1897 (above) and in 1908 (below), was a luxury allowing for citrus trees to be kept year-round, protected from the winter weather and moved out into the garden in the summer. Built around 1820 in the form of a Grecian temple, it had a rubble-stone foundation, two walls of masonry, and two walls (south and east) made of full-height triple-hung windows. The interior was heated naturally as well as through a hypocaust, a wood-burning furnace connected to an under-floor system that allowed for heat to radiate around the perimeter of the room. The Ridgelys had one of the most extensive collections of citrus trees and plants in the United States during the mid-19th century.

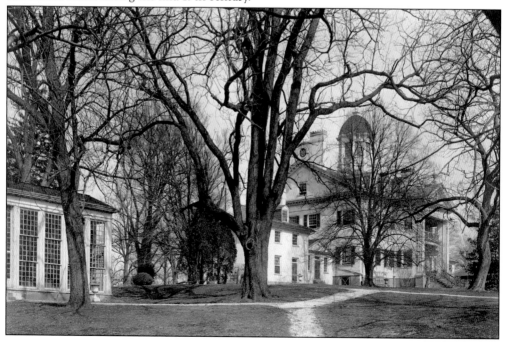

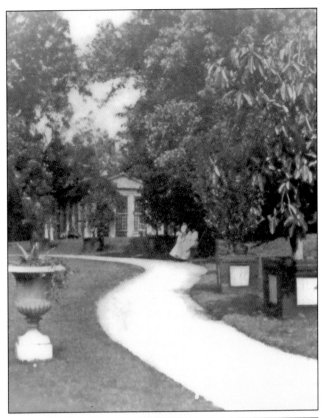

These are *c.* 1900 views taken along the serpentine path that encircles the Great Terrace on the southern side of the mansion. The orangery is visible in the background of the top photograph and the west wing and hyphen in the lower one. Marble urns are strategically placed along the path, drawing the architecture of the house into the garden. Citrus trees in large paneled boxes can also be seen along the path, having been moved outside from the orangery. Three unidentified girls, possibly daughters of John and Helen Ridgely, are seated on a bench in the top photograph.

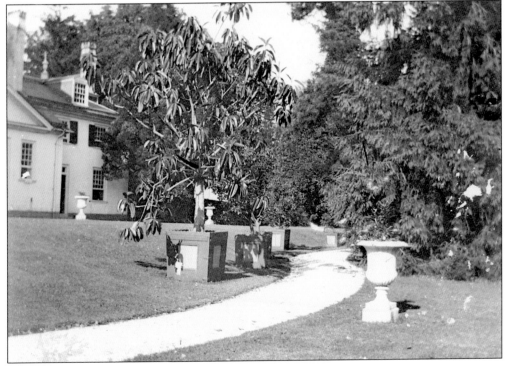

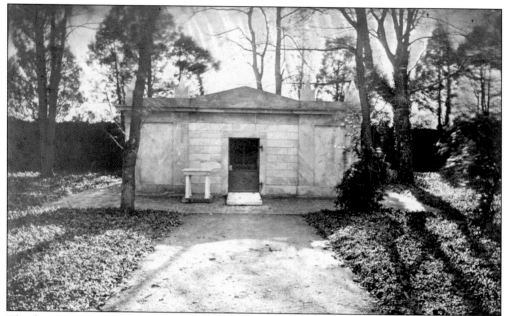

The family cemetery at Hampton is enclosed with a brick wall and iron gates and has a large Egyptian Revival–styled vault as well as in-ground burial sites, most marked with simple horizontal or vertical tombstones. The cemetery was required as part of Captain Ridgely's will and was begun after his death. The vault shown in the c. 1910 photograph above is constructed of gray marble blocks on three sides with a brick back wall. The c. 1890 photograph below shows some of the grave sites. The two in the foreground are of John Campbell White, Eliza (Didy) Ridgely's first husband, and John Ridgely White, their infant son. Only two non-family members, both beloved by the Ridgelys, are buried in the cemetery: Nancy Davis, a former slave, and Selena Davis, a servant.

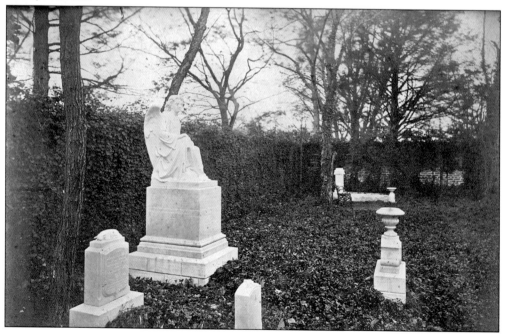

While the terraced garden saw several different planting schemes as the workforce changed, a c. 1920 view of the north lawn shows that no major changes have been made to this landscape. The view toward Hampton Lane and the home farm to the north remain the focal point.

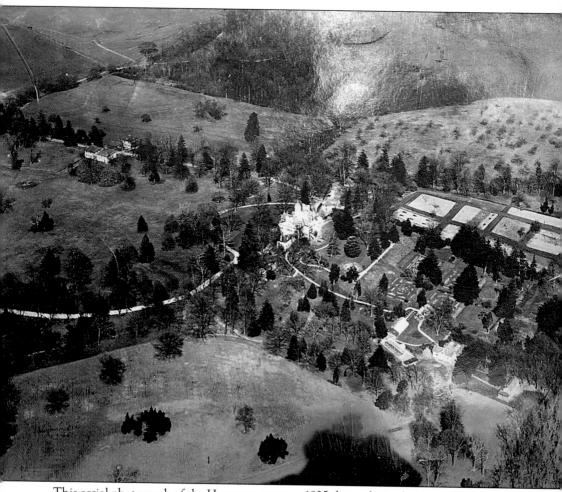

This aerial photograph of the Hampton estate *c.* 1925 shows the undeveloped acres and wooded areas surrounding the mansion before the growth of suburban development, which today encircles the property. The 1930s would see the beginning of the Ridgely-backed residential development that eventually formed the Hampton neighborhood seen today. The mansion is clearly visible, as are the historic roads and pathways, which are still being used. The contrast in design between the naturalistically styled north lawn and the formal terraced garden is quite visible. Many of the outbuildings can be seen, including the two stables and the carriage house (demolished) along the top edge of the north lawn and the greenhouses at the edge of the terraced garden. The checkerboard pattern indicates the location of the large terraced orchard to the east of the gardens.

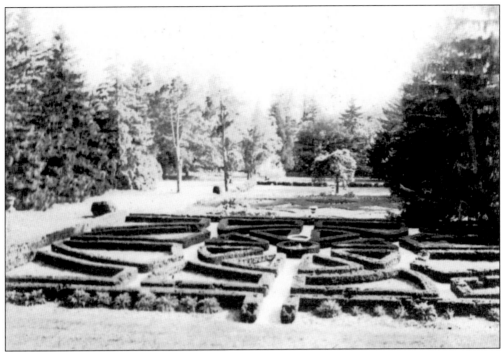

These two photographs are images of Parterre No. 1 around 1920. In the top photograph, a specimen tree is visible in Parterre No. 3 in the background, but there are only minimal plantings in the rest of the parterre. The lower photograph shows that while the boxwood was well tended and there are what appear to be rose bushes along the outer edge of the parterre, there is little other landscaping such as bedding plants. This was the height of decline in the gardens, as the change in the Ridgelys' financial status forced them to focus their spending more on necessities.

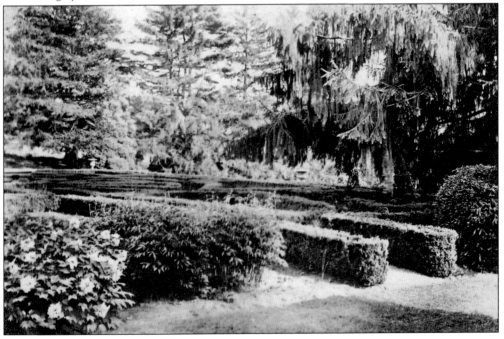

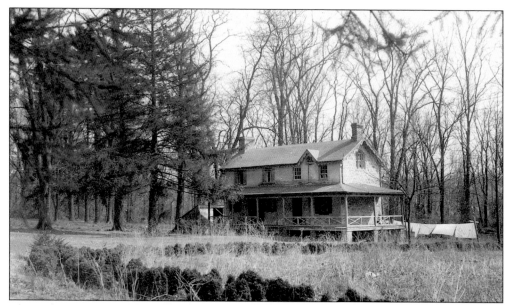

This is the caretaker's house, also known as the gardener's house, c. 1935. It is a two-story gable-roof farmhouse with a wraparound porch built in the early 19th century with an addition by the mid-19th century. It is located near the southern boundary of the Hampton estate, just south of the garden maintenance building adjacent to the terraced gardens. The house was provided to the head gardener, a well-respected position at Hampton, in acknowledgement of his status on the estate.

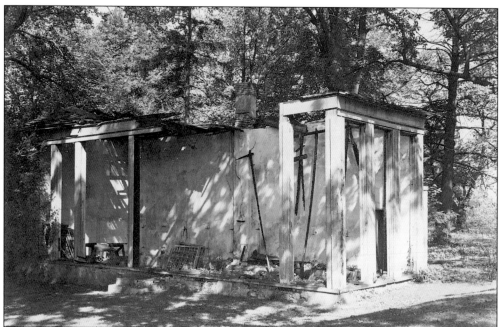

The original orangery was destroyed in a fire in the late 1920s, and all that remained is pictured here around 1936. It was reconstructed by the National Park Service on the original foundations in 1975–1976 using historic photographs and archaeological evidence. (Historic American Building Survey collection.)

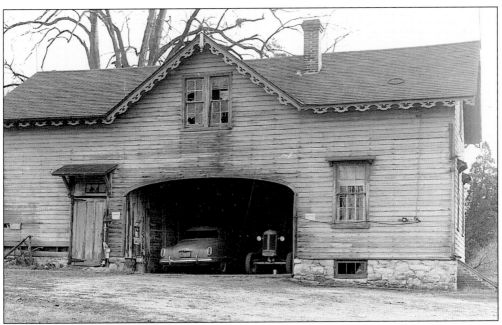

The garden maintenance building seen in these *c.* 1950 photographs was built in the latter part of the 19th century and is located between the greenhouses and the caretaker's cottage beyond the terraced garden. It is a one-and-a-half-story wooden-frame structure on a rubble-stone foundation. The central section housed mowers (originally horse-drawn) and other large-scale equipment to begin with and then was used for cars and gas-powered equipment. One of the side bays was used as a feed room and a stable with a hayloft above. The last bay was used as living quarters for a succession of employees including gardeners, groundskeepers, and a chauffeur. This section of the building has a partial cellar. Foundations for the cold frames can be seen in front of the building in the lower photograph.

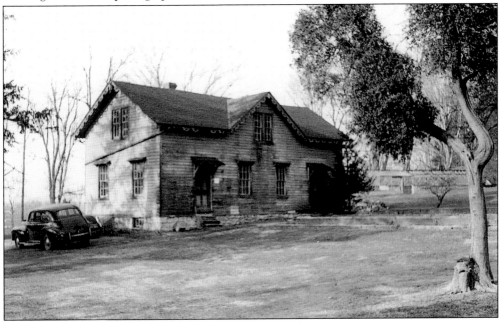

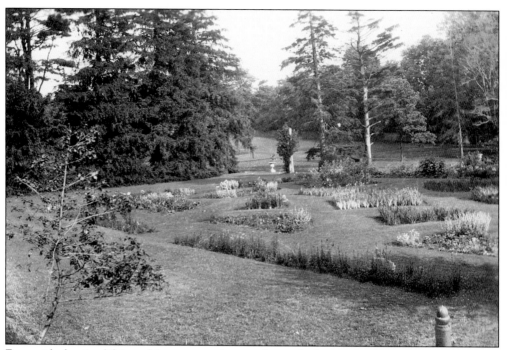

Even with the simplifying of the parterre designs that took place around 1900 in order to reduce maintenance costs, most of the parterres were returned to grass. Lillian Ridgely focused a great deal of her energies on the terraced garden, bringing back hints of its former grandeur. Shown c. 1940 are the beginnings of her efforts. The lower photograph is a view looking toward the bottom of the garden with Parterres No. 2, 4, and 6 visible.

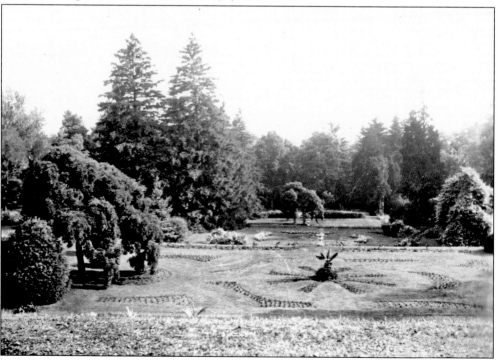

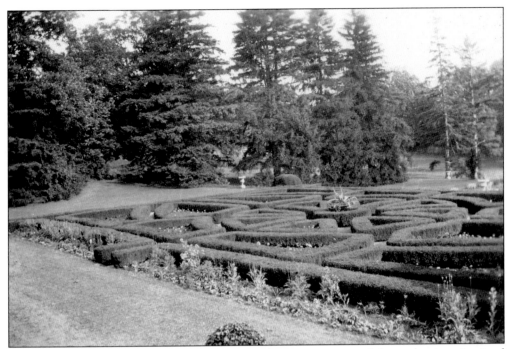

Interestingly the photograph of Parterre No. 1 at the same time period shows that it maintained the original boxwood design. It is almost as if this parterre was a treasured family heirloom remaining as a reminder of how the overall terraced garden appeared in its heyday.

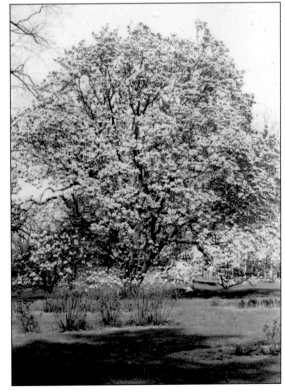

Landscape design at Hampton throughout its history incorporated specimen trees, including this saucer magnolia (*Magnolia soulangiana*), seen around 1940. It is located near the greenhouses. Currently Hampton National Historic Site has claim to three state-champion trees, an Austrian pine (*Pinus nigra*), a pecan (*Carya illinoinensis*), and a weeping Japanese scholar tree (*Sophora japonica pendula*).

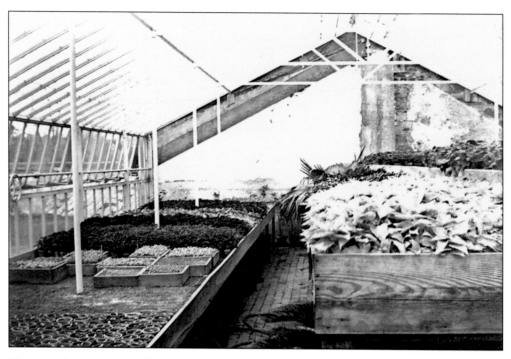

The greenhouses were in full use for seasonal plantings as Lillian Ridgely tried to retain and maintain some of the historic landscape designs. Various types of ground covers, flowering plants, and some exotics are shown here getting a head start on spring. At one time, there were a number of other specialized gardening-related buildings, including a fernery, a grape house, and a rose house.

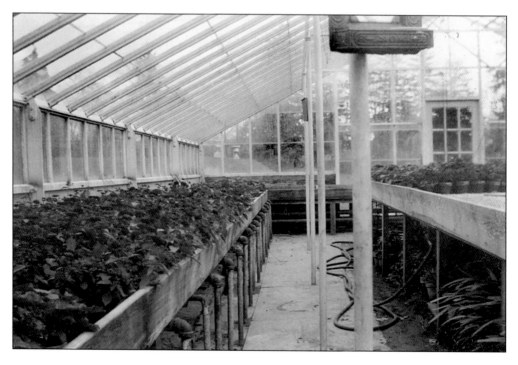

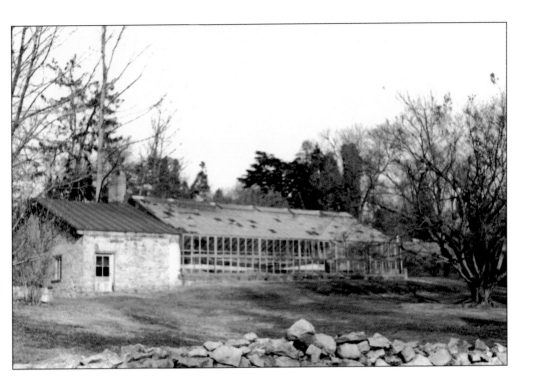

By the 1960s, the two remaining stone-and-glass greenhouses at Hampton had fallen into disrepair. They sit as silent markers of an era of grandeur that no longer exists in the landscape at Hampton. Some restoration work has been undertaken in the years since these photographs.

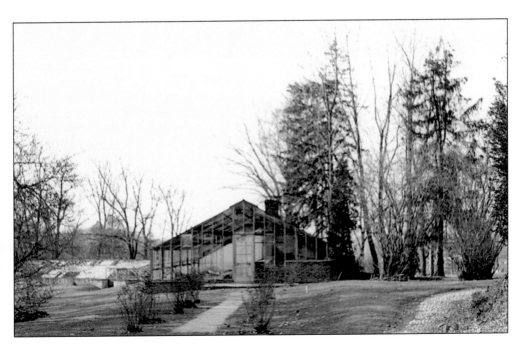

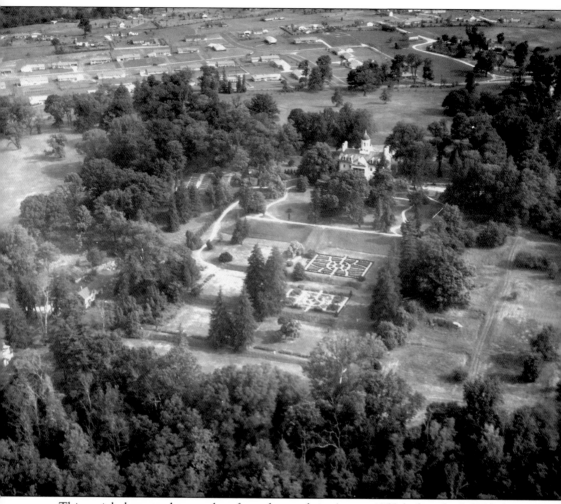

This aerial photograph was taken from the south in August 1955, before the I-695 beltway was constructed in the woods along the lower edge. It is a fascinating image showing the mansion and its immediate landscape as an island within a suburban neighborhood. Much has changed in the landscape, and yet the basic elements of the mansion, with its terraced gardens, remnants of the adjacent orchard, and the naturalistic north lawn, remain. Two of the garden parterres retain some integrity of plantings, but the Great Terrace and three additional terraces are easily identified. The home farm property can be seen in the upper right corner, and several other additional buildings no longer standing are visible tucked in the woods between the properties.

Two

HAMPTON MANSION

Hampton mansion, built between 1783 and 1790, is an outstanding example of late Georgian architecture in America and possibly the largest private residence in the United States at the time of its completion. Its design was probably a collaborative effort between Capt. Charles Ridgely and Jehu Howell, a highly skilled master carpenter. Accentuating its large scale and grandeur, the mansion sits on the highest point on the current estate grounds. Typical of Georgian architecture, it has a symmetrical five-part linear plan formed by a large central block connected to two wings by hyphens. Constructed of gneiss-schist rubble stone, the house was covered with stucco and scored to resemble fine-coursed ashlar masonry. The style is further emphasized by large, central, two-story, wood-detailed projecting porticoes, dormer windows, and a large cupola. Formerly a wooden shed-like summer kitchen (demolished in 1950), an early feature to the house, was connected to the east end of the house at the kitchen wing.

The house was built on a massive scale, with large public rooms in the first story of the main block and supporting rooms in the wings and hyphens. Designed to make a statement and for large-scale entertaining, the first story includes a large central hall and a pair of rooms on each side. Unlike most extant five-part Georgian houses in Maryland, Hampton's main staircase is not located in the central hall but is placed on the east side between two smaller parlors in a side hall, allowing the great hall to be used for large dinner parties, a ballroom, and a reception room. In bad weather, the Ridgely family used this space for different activities, including walking, art appreciation, and children's games.

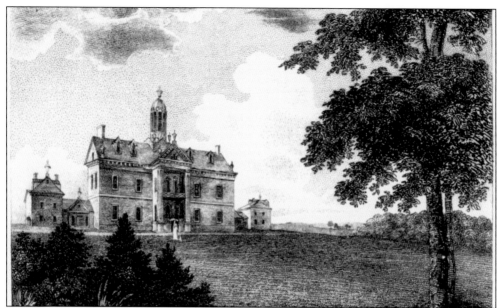

This engraving of the north facade of the mansion, the earliest view of Hampton in its collections, was done by William Russell Birch and published in 1808. The drawing for the engraving was probably done during his visit to the Hampton estate in 1801. English born, having immigrated to Philadelphia, he became a well-respected American artist, producing many architecturally related engravings and watercolors along with portraits of leading figures of the time period.

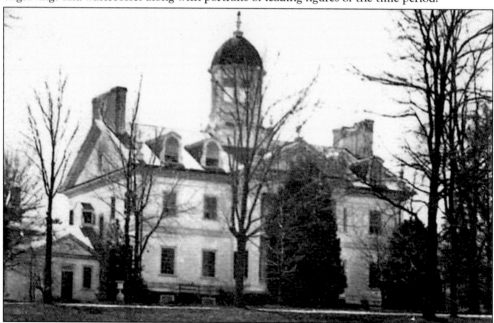

A c. 1861 photographic view mimics the view of the north facade shown in the top photograph. The immense scale of mansion, especially the central block, can easily been seen when compared to the landscaping around it. Unlike most houses of the time period, the mansion was stuccoed and scored to look like stone. The oversized cupola gives added architectural distinction to Hampton while also being part of the natural ventilation system in the house.

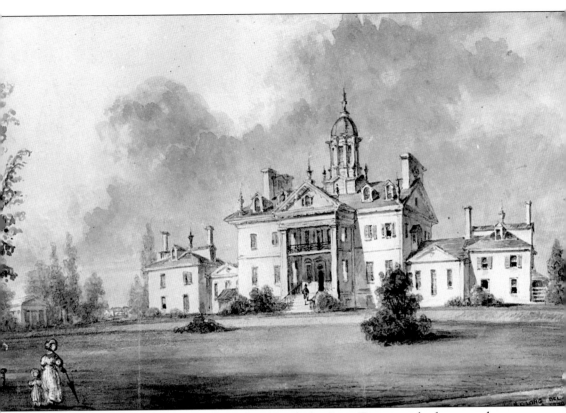

This watercolor of the south façade of the mansion with the Great Terrace in the foreground was painted by Robert Carey Long Jr. in 1838. He was a noted early-19th-century Baltimore architect who favored the Greek Revival style but was also interested in architectural history. The view of the mansion shows the five-part plan typical of the Georgian style: a multi-story central block with matching wings and hyphens on either side. The mansion would have appeared quite imposing at this time, with little or young landscaping surrounding it compounded by its siting on the high point of the property. Note this early indication of the summer kitchen on the east wing.

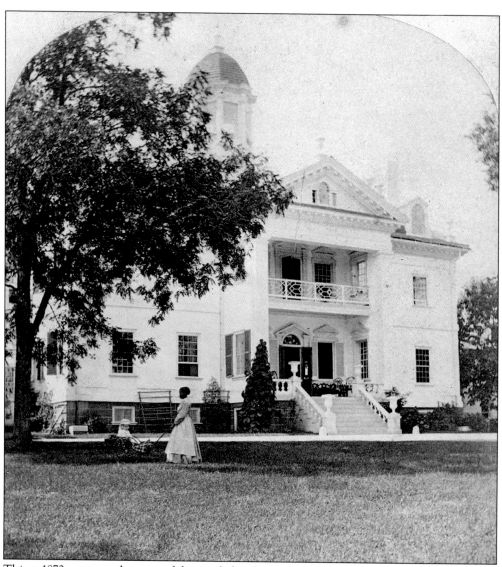

This *c.* 1872 stereograph image of the north facade is one of a number of stereograph cards made of Hampton, including both views of the mansion and the landscaping. It highlights the north portico, which, mirrored on the south elevation, gave the Ridgelys protected outdoor living space. This portico was the public one, as it faced the entry drive. Its steps and railings were redesigned in the 1860s and were reconstructed out of marble with more elaborate detailing, including urns to match the garden urns. The wooden first floor of the portico was also updated to the black-and-white checkered marble floor that still exists. In front of the mansion, an African American servant can be seen pushing a young child in a carriage.

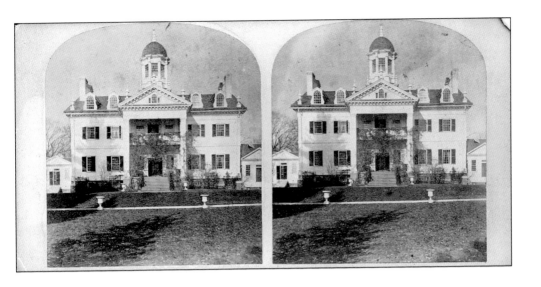

Two more stereograph images, c. 1872, show the south facade of the mansion and a view of the great hall. Above, shadows of landscaping can be seen on the Great Terrace as well as trellis frames against the mansion and two garden urns framing the portico. The south portico is partially covered in wisteria vines trained to climb the walls and extend across the second-floor balustrade. This view of the great hall is the earliest-known interior view of the mansion. The great hall is furnished with groupings of furniture with slipcovers, walls filled with framed art, and animal-skin rugs. The large Chinese porcelain vases seen in this image were purchased for display in the hall.

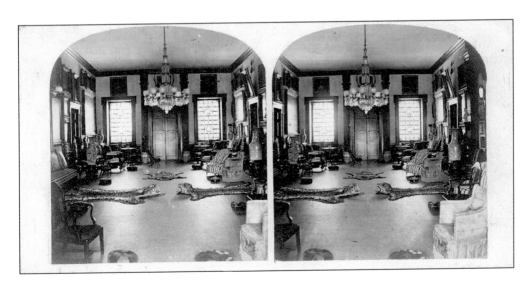

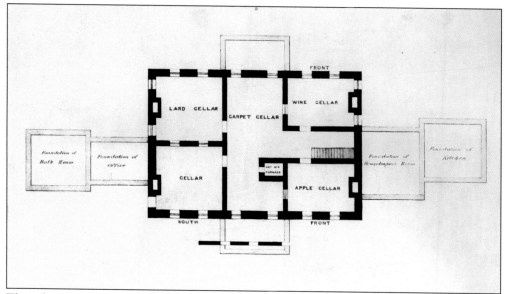

These four drawings are a set of architectural plans of the mansion drawn by John Laing in 1875. Although full height, the basement at this time just extended under the central block of the mansion and was used for storage. The individualized rooms were noted as a lard cellar (left), carpet cellar (central) with small area noted as hot-air furnace, and apple cellar and wine cellar (on right). On the ground floor of the main block portion, the drawing and music room were to the left (west) of the great hall, while the dining room and sitting room were to the right (east). The west wing and hyphen had an office and an early bathroom in it. The kitchen and housekeeper's room were in the east wing and hyphen.

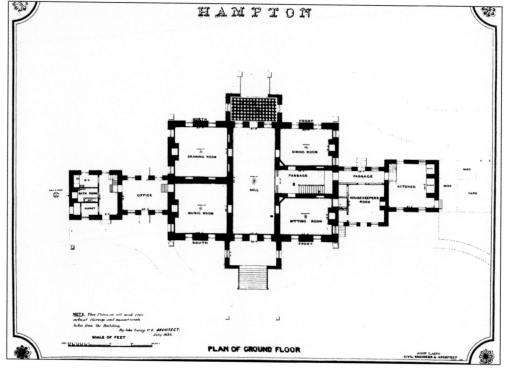

46

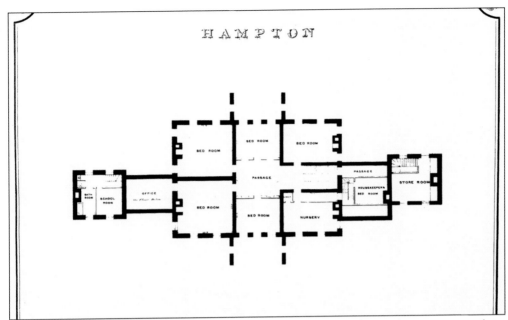

The second floor of the main block of house had six bedrooms. The southwest room, with its good natural lighting, was the master bedroom. The southeast bedroom was reduced in size to allow access to extended back stairs. It was further altered to allow the addition of a bathroom. The east wing and hyphen contained the housekeeper's bedroom, reached by the back stairs, and storage accessible from a stair in kitchen. The west wing appears to have had a school room and another bathroom accessible from ground level. The third floor had eight main bedrooms with two large storage rooms (also used as bedrooms) and access to the cupola. This floor was mainly the domain of the children and their nannies or governesses. It was also used for less important guests and family members when needed. There is no third level on the wings and hyphens.

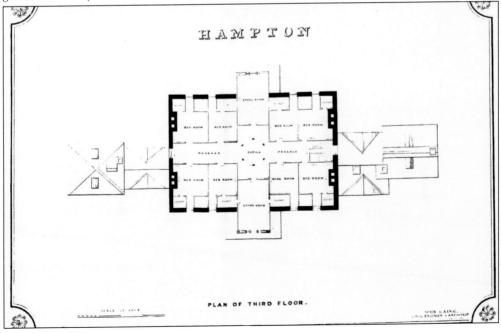

PLAN OF THIRD FLOOR.

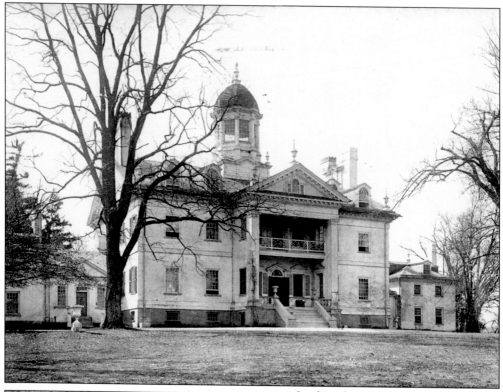

Looking back from the north lawn, one gets a good view of the northern facade of the mansion in this c. 1900 photograph. The classical detailing of the window surrounds on the portico, the cornice, and the cupola can be appreciated in this magnificent Georgian mansion. Note the use of louvered shutters on the doors and windows at the portico to provide privacy while allowing for natural ventilation.

This c. 1908 photograph is taken from the heart-shaped drive showing the view as one would have arrived via carriage. The contrast in size of the main central block and the wings/hyphens is quite noticeable. Notice the use of shutters on the west-facing windows of the central block. The marble urns incorporated into the design of the portico stair blend with the urns found in the landscape.

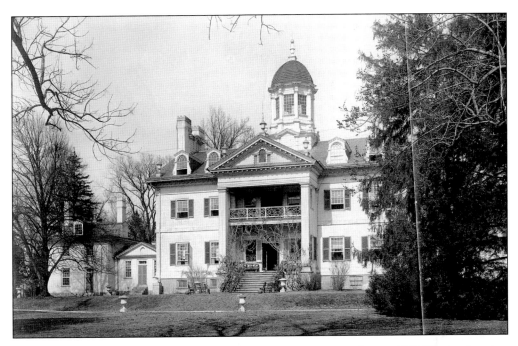

These two photographs of the southern facade of the mansion were taken in 1908. The landscaping has matured, and wisteria vines cover the portico when in season. There are louvered shutters on all the windows and doors of the main block, providing privacy and shading while still allowing for natural ventilation. The wooden summer kitchen can be seen in the lower image in a kitchen yard shielded from the gardens by a hedgerow. In both images, the terracing of the landscape is visible with the mansion sitting on the highest plateau and a short drop to the Great Terrace area with the terraced gardens beyond (out of the photograph).

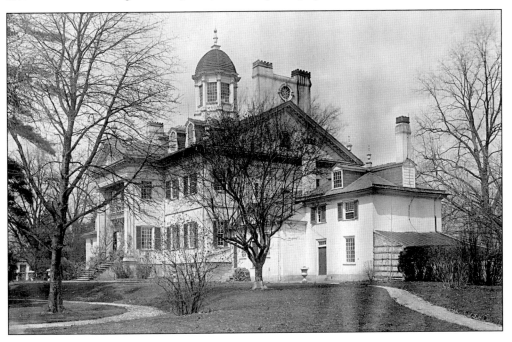

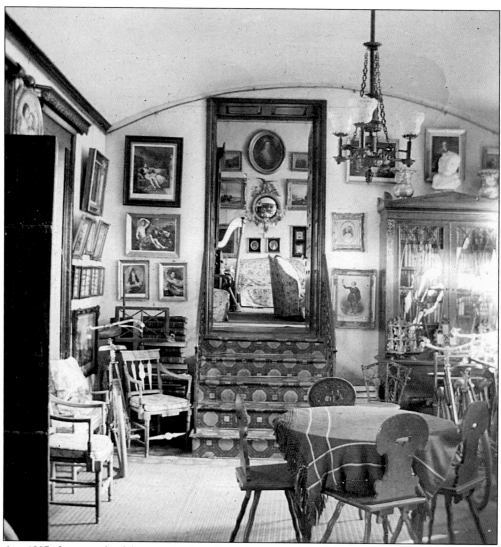

A c. 1897 photograph of the west hyphen shows this room furnished as an office or study. Artwork fills the wall space, a music stand rests in the corner, and a bookshelf full of books and several sitting areas await scholars and others who are at work. Two bicycles are parked on either side of the room. Visible through the open door is the music room beyond. Eliza's harp, slipcovered furnishings, and more artwork on the walls can be seen.

This is a photograph of the northeast corner of the music room taken c. 1897. Eliza Ridgely's harp stands next to a large secretary bookcase filled with books. A stag's head hangs above it with numerous paintings, both portraits and landscapes, filling the walls. The furniture includes a slipcovered confidante, armchair, and oval-back sofa. A chandelier with a Chinese porcelain font hangs from the ceiling, centered over a tapestry-covered oval table.

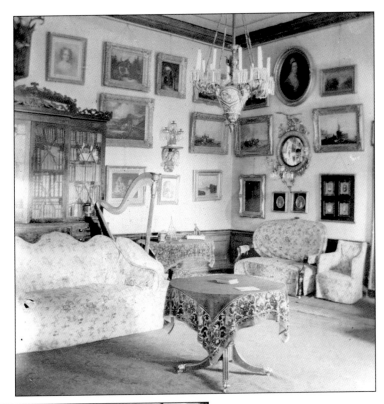

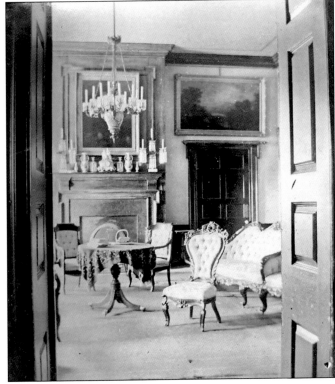

This c. 1895 photograph of the music room looks in the opposite direction, standing in the doorway at the great hall looking back toward the door to the west hyphen. Here the furniture, including the matching silk-upholstered armchair and confidante, can be seen without slipcoverings. There is a large landscape painting over the far door.

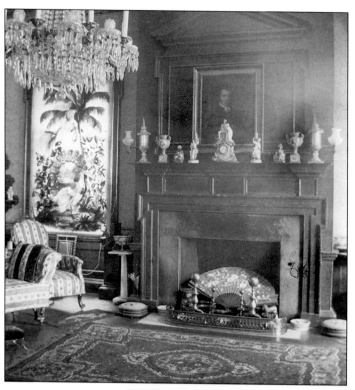

These two photographs are of the drawing room c. 1897. The top view looks toward the southwest corner and the bottom toward the southeast corner. In the top view, one of the painted window shades can be clearly seen to the left of the fireplace. The large gilded mirrors seen in the lower image were hung within wood frame surrounds that mimic the window surrounds opposite. The marble bust on a pedestal is of Charles Ridgely (1830–1872). The door reflected in one of the mirrors leads to the great hall. The upholstered furniture is slipcovered in both views.

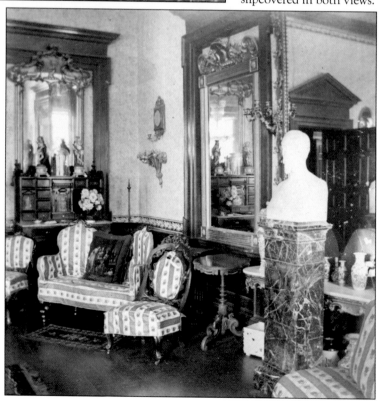

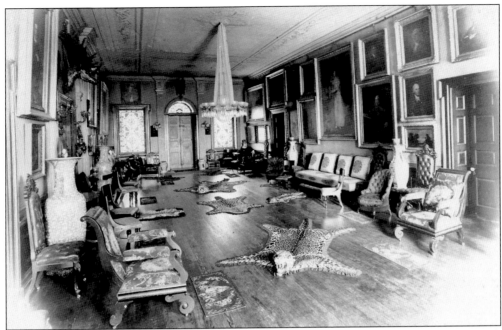

This summertime photograph of the great hall (above) was taken around 1900 from the north end, providing an almost full-length view of the room. The stained-glass south windows are visible, as is an original chandelier covered in insect netting. Sofas, chairs, and large Chinese vases line the walls, which are filled with family portraits, including the portrait of Eliza with her harp. The ceiling is painted with a delicate border pattern. The floor is uncovered except for scattered animal-skin rugs and small rugs in front of the armchairs. The lower photograph, taken in 1908, shows a view of the wall to the northeast. The door in the large archway, originally an open arch, leads to the stair hall. Another original chandelier can be seen in more detail.

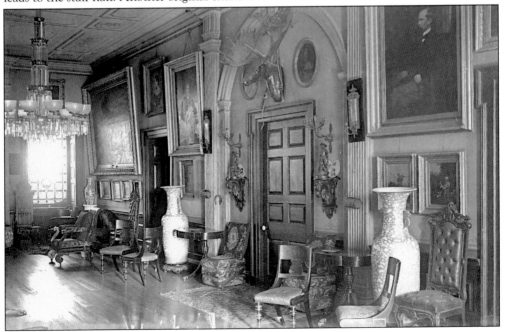

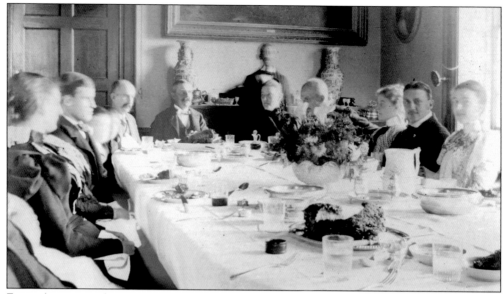

Entertaining was a large part of life at Hampton throughout its history, and the meal was a central part of most of these events. These c. 1897 photographs appear to be two images of the same dinner party in the northwest corner room. In the top photograph, there are five men and four women visible. Helen W. S. Ridgely is at the end of the table, and an African American stands directly behind her in front of the sideboard. The door in the background leads to the great hall. The party in the lower photograph is made up of seven people, including both adults and children. An African American servant stands in the background next to the fireplace. Portraits of Charles Ridgely (1733–1790) and his wife, Rebecca Dorsey Ridgely, hang above the mantel. The door partially seen in the background opens to a wall cupboard on the south wall.

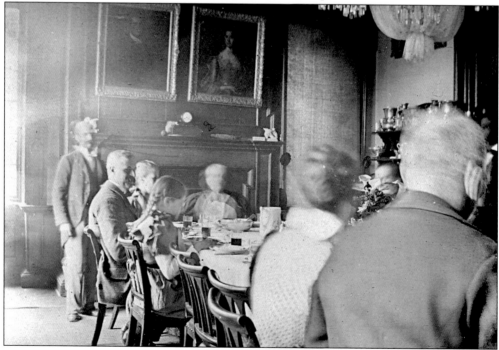

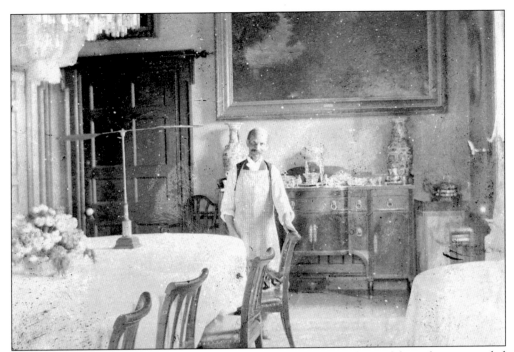

This *c.* 1895 photograph of an unidentified servant is a reminder of the workforce that was needed at Hampton. He is shown in a work apron holding a feather duster, dusting off the dining chairs as he readies the northeast room for a social event.

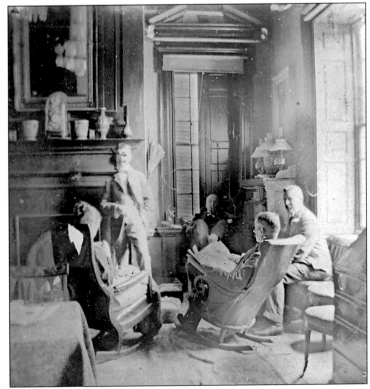

This group of five adults—four men and one woman—clusters near the large corner windows in the southeast room of the mansion, taking advantage of the natural light in this *c.* 1895 photograph. Empty curtain rods hang above roll-down shades at the windows. A covered table and a desk are visible in the foreground. A domed mantel clock sits centered between porcelain vases on the fireplace mantel.

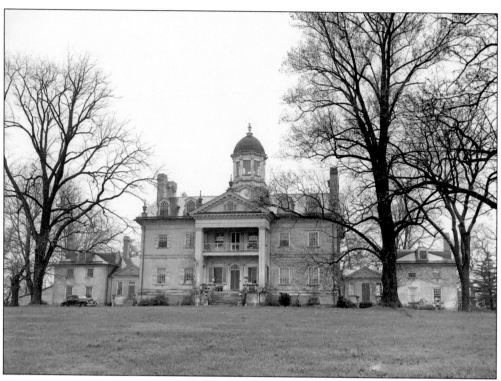

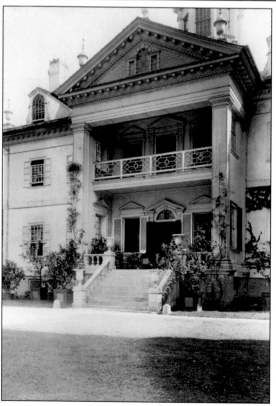

This 1935 image of the north facade of the mansion is a timeless one, showing little change from previous decades. The vegetation has continued to mature and in some areas such as the west wing has been allowed to grow over the building. The windows on the portico and those to the left of it have louvered shutters, as do the entry doors and doors on the hyphens. The coupé parked in front of the east wing is the only clue to the modern date of the image. The close-up of the portico, c. 1920, allows for careful study of its classical detailing, especially at the windows and doors within. Operable side windows provided additional ventilation to the portico spaces, and the Ridgelys used them extensively. The Chippendale-style rail at the second story is original, but the stairs and rails were redesigned in marble during the 1860s.

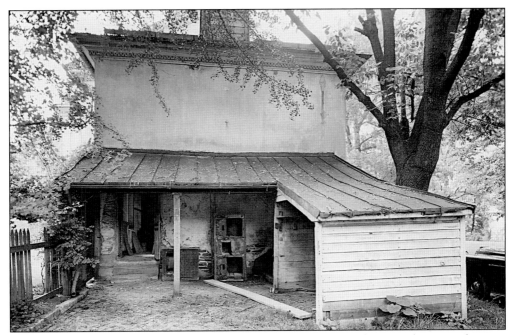

While the west side of the mansion was on public display, the east end was much more utilitarian. This wooden, shed-like structure served as the summer kitchen for the mansion while the Ridgelys owned it. This 1949 photograph shows an *L*-shaped structure, but the extended leg was added in the 20th century. It was demolished not long after this photograph was taken.

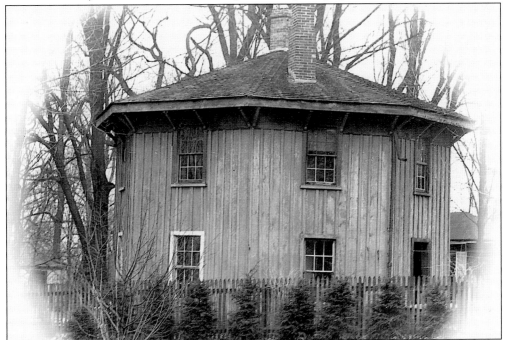

This 1930 photograph shows the wood-sided octagon building located just east of the mansion in the kitchen yard. Built sometime in the mid-19th century, it housed servants who worked at the mansion. It burned down in 1945, and all that remains are its brick foundations.

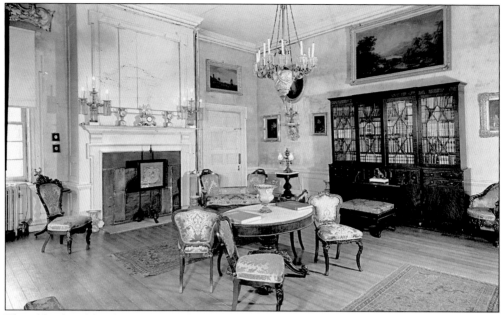

The table, chandelier, large secretary bookcase, and landscape painting seen in this 1948 photograph are elements of the music room seen in historic photographs. An end of the confidante is visible at the right side of the image. One of the original cornices can partially be seen but not the accompanying elaborate window treatments and painted window shades. There are also many fewer works of art on the walls than in earlier images.

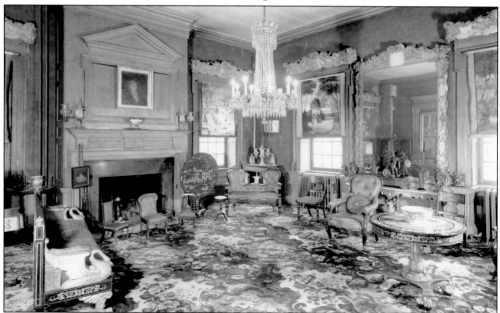

The drawing room retains much of its historic feel in this 1948 photograph looking toward the northwest corner. The 1832 Finlay swan sofa and matching round table to the right are pieces of original furniture, as are the 1840s tete-a-tete and armchair. The carpet was made for the room in 1850. The windows retain their ornate cornices and painted window shades, and at least one of the large mirrors still hangs on the wall.

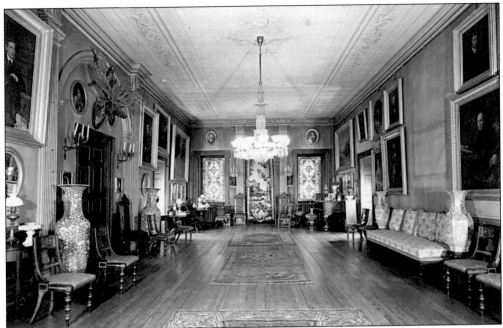

This view of the great hall looking south was taken in 1948. Elements from older images can still be seen, including the delicate stenciling still existing on the ceiling, the small Turkey carpets, some of the furniture, and the porcelain vases. While the walls remain filled with beautiful works of art, the space is where the painting of Eliza Ridgely, *Lady with a Harp*, used to hang.

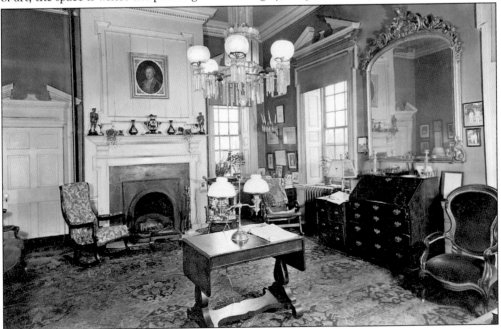

The southeast room on the ground floor was used as a sitting room when this photograph was taken in 1948. In the center of the room is a drop-leaf lamp table with a double student lamp. There are several rocking chairs clustered by the fireplace and near the large windows to capture warmth and natural light. A very large, elaborately framed mirror hangs over a drop-leaf desk.

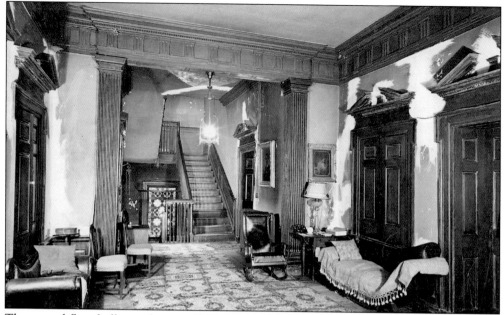

The second-floor hall, seen here in 1948, is one of the most impressive spaces in the mansion, with its classically styled door surrounds and frieze. The doors behind the reclining sofas give access to large shallow closets for hanging traveling clothes and other storage. A rocking chair, several side chairs, and tables all help to create this space as a sitting area. A stained-glass window can be seen in the outer wall of the stairway.

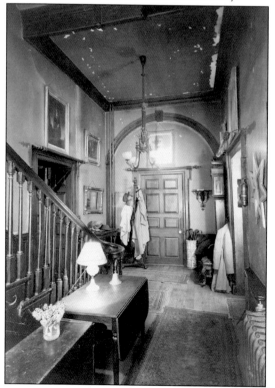

This 1948 photograph of the first-floor stair hall gives visual clues to the financial challenges facing the Ridgely family as they tried to maintain the mansion. A coat rack, umbrella stand, and drop-leaf tables are visible and well used, as this served as an entry hall during this time period. The door within the arch in the background leads into the great hall.

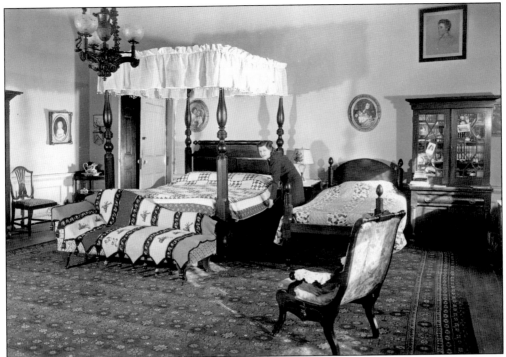

Jane Ridgely, wife of John Ridgely Jr., is shown making the bed in the master bedroom in 1948. (Photograph by A. Aubrey Bodine, copyright Jennifer B. Bodine, courtesy of aaubreybodine.com.)

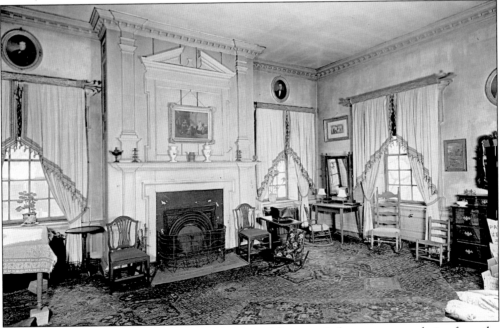

An interior guest room in 1948, this room retains elaborate window treatments dating from the 19th century. A mix of adult- and child-sized furniture including a small rocking chair can be seen in the room.

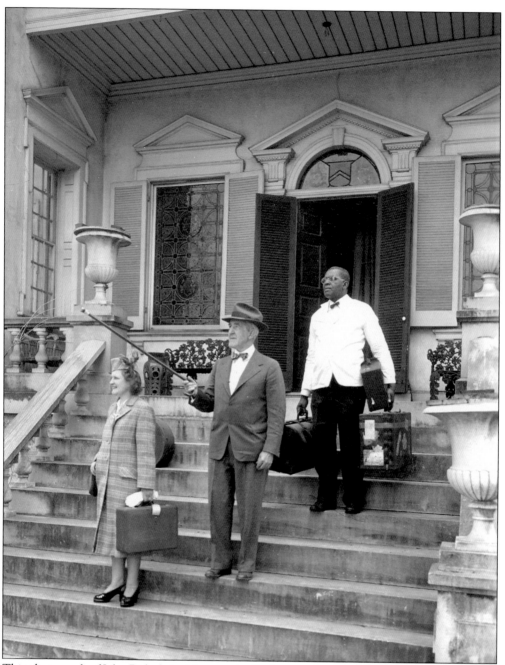

This photograph of John Ridgely Jr., his second wife, Jane, and an unidentified African American servant taken in 1948 shows what must have been a bittersweet moment. It captures the Ridgelys' move to the Farm House after completing the agreement that would make Hampton a National Historic Site. The mansion was saved, but it was also the end of more than 300 years' ownership of this grand estate. John Ridgely Jr. seems have a positive perspective as he gazes toward the Farm House from the stairs of the north portico of the mansion, indicating "Onward!" with his raised cane. (Photograph by A. Aubrey Bodine, copyright Jennifer B. Bodine, courtesy of aaubreybodine.com.)

Three

THE PEOPLE OF HAMPTON

While the buildings and grounds provide the current-day visitor with an immediate picture of the Hampton estate, it is only through the people who inhabited it that we can begin to get the full story of it. Portions of this property were acquired by the Ridgely family from as early as 1745, when Col. Charles Ridgely started buying forested land out in the country looking for raw materials to support his ironworks. His son, Capt. Charles Ridgely, had the vision to create a vast empire, continuing to buy land, developing his mercantile and ironworks businesses, and building a grand country estate, today known as Hampton National Historic Site. The Hampton estate saw six masters until John Ridgely Jr., who when faced with seemingly insurmountable odds first tried to save the mansion by forming a development company to build houses on Ridgely lands, hoping to raise money for the mansion's upkeep. Finally, with the assistance and generosity of other concerned citizens, he succeeded in saving the mansion for posterity as part of the National Park System. But Hampton is more than just these Ridgely men; it includes a complementary group of strong Ridgely women and a large supporting cast of laborers, craftsmen, and servants, enslaved, indentured, and free.

We can meet these people through the rich resources of Hampton National Historic Site's archival collections. Written documentation, though mainly recorded from the perspective of and about the Ridgely family, does give clues to the other people living on the site. Bills of sale for servants and reward notices for runaway slaves show the harsh reality of the workforce at Hampton but can be contrasted with the list of Christmas gifts to be given to "colored children" kept by Eliza (Didy) Ridgely. Images, both portraits and later photographs, show us literally the family and a few of the people, mostly unidentified, who worked for them. Among the most endearing are the images of children, whose costumes may change while their innocent delight in play changes little from generation to generation. It is through these human images of Hampton that the many voices can be heard.

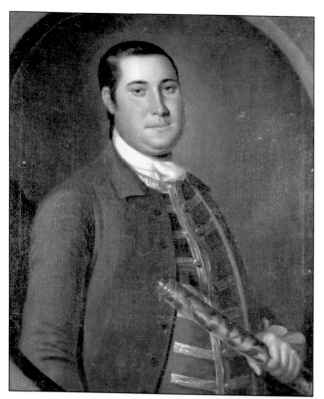

Charles Ridgely (1733–1790), seen in a c. 1770 portrait by prominent Colonial-era American portrait artist John Hesselius, was the builder of Hampton mansion and is referred to as its first master. Known as Capt. Charles Ridgely for his seafaring days, he is painted holding a telescope in his left hand. He amassed his fortune from his ironworks, mercantile, and agricultural endeavors.

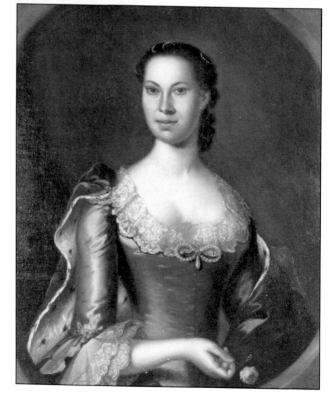

This c. 1770 portrait of Rebecca Dorsey Ridgely (1739–1790) by John Hesselius shows a very elegantly dressed young woman, as befitted the wife of Charles Ridgely. Her overall demeanor changed in later years, as she embraced the Methodist religion and became one of its staunch promoters. The Ridgelys provided free housing for Robert Strawbridge, considered the first Methodist preacher in America.

Captain Charles Ridgely _____ *art by Plunket.* Dr

1786		
July 26	To 9 Servants Sold you payable 1st Novemr for	£151.10.0
31	To 2 ditto — ditto — payable ditto	30.0.0
Aug 10	To 8 ditto deld Cromwell payable 10th November	132.0.0
Feb 13	To 8 ditto deld ditto payable 1 December	127.0.0
	To 8 ditto deld Hen Howard payable 15 Decemr ✓	136.0.0
		576.10.0

Supra Cr

Octr 31	By our Order to Richd Lawrence 3 Ton Iron	81.0.0		
	By Daniel Sheridans Order on Wm Mathews	136.0.0	217.0.0	
	payable 15th December next			
		due S & Plunket	359.10.0	

Note of the above ballance due 1st November ... 100.10.0
due —th ditto ... 132.0.0
due 1st December ... 127.0.0 £359.10.0

Sir

We have received your favour pr Mr Sheridane, whom we would
gladly have furnished with a Servant, but had not one left. Above
Is the Statement of your accot, by which you'll perceive that after Credity
you with three Tons of Iron deld Mr Lawrence, and Mr Sheridanes
Order on Wm Mathews pble 15th Decemr there is in our favour a ballance
of £359.10 - of which £100.10 - is due to Marraw £132 - on the tenth of
November & £127 - on the first December, as we shall want the money
much at the different periods it becomes due, we must Request
if you set out for Annapolis, that you would leave Orders with
us on your friends in Town, that we may call upon them for
the amount as due Which will particularly Oblige Sir

Your obedt Servants
Captain Charles Ridgely _____ Stewart & Plunkett
October 31st 1786

This receipt details the purchase of five servants or indentured servants by Capt. Charles Ridgely. As cash/currency was in short supply following the Revolution, a portion of the payment is in iron. It is signed by Stewart and Plunkett and Captain Ridgely and dated October 31, 1786. At this time, a combination of indentured servants and enslaved peoples labored at Hampton and the ironworks. This would shift to mainly enslaved labor in the pre–Civil War 19th century.

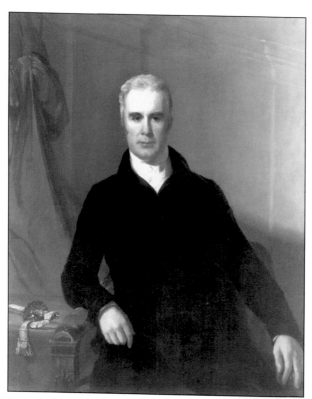

Charles Carnan Ridgely (1760–1829), the second master of Hampton, was painted by Thomas Sully in 1820. Hampton saw a great period of improvements under the watchful eye of Charles Carnan, who had been well schooled to take on this ownership position by his uncle, Capt. Charles Ridgely. More refined than his uncle, he further developed the landscaping plans and interiors of the mansion, as well as continuing the family interest in Thoroughbred horses and ironworks. (Thomas Sully, *Charles Carnan Ridgely*, gift of Mr. and Mrs. John Ridgely, Image © 2007 Board of Trustees, National Gallery of Art, Washington.)

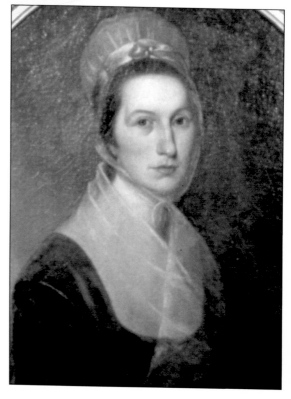

Priscilla Dorsey Ridgely (1762–1814), the wife of Charles C. Ridgely, was painted in an austere style of dress, as was typical of Methodists at the time. This is a copy portrait of one by Rembrandt Peale now located at Maryland State House. She was the youngest sister of Rebecca Dorsey Ridgely. Most of Priscilla's energies were focused on raising her family of 14 children to be good moral citizens.

These two images are early-1860s *carte de visite* prints of John Carnan Ridgely (1790–1867), third master of Hampton, and his second wife, Eliza Eichelberger Ridgely (1803–1867). John was the second son, who was never meant to inherit this estate and thus did not receive training to be a master of Hampton. Eliza was the only child of a prominent merchant, Nicholas Greenbury Ridgely; she was an exceptionally accomplished and well-educated woman. Wealthy in her own right and having a sophisticated sense of design, Eliza was behind many changes at Hampton. As an avid traveler, she purchased items abroad to blend with furnishings purchased in the United States. With her great knowledge and interest in horticulture, the gardens and grounds saw additional landscaping, and a number of outbuildings were constructed. Gas lighting and central heating was added to the mansion, and most rooms were redecorated in the latest fashions.

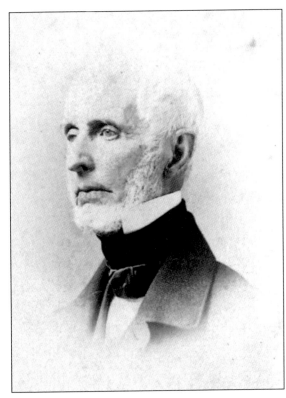

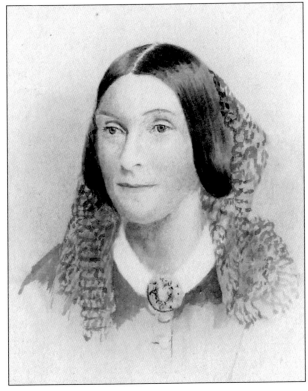

CHRISTMAS GIFTS of the Colored Children of Hampton, given by E. Ridgely

YEARS	1841	1842	1843	1844
Harriet Davis	A doll	A doll	Too old to receive toys	
Hester Baker	Doll's room	A doll	Churn & doll	A doll
Ellen Davis	A chair & a doll	Box of cups & saucers	A Boy doll	A doll
Augustus Gibbs	A harmonica	From bad behavior put out of the house		
Joe Pratt	Tin soldiers on horseback	Bag of marbles	A trumpet	A drum
Caroline Pratt	A book case	A doll	Box of cups & saucers	A doll
Lewis Davis	Tin Drummer	A trumpet	A drum	Box of ninepins
Eliza Wells	A doll	(Not to receive any gift)	Indian pipe	Box of cows
Amanda Wells	A doll	(Apprenticed to Miss Witkin)	Cradle & doll	Cups & saucers
Jem Gully	Leaden Goat	A drum	Man & horse	A trumpet
Jem Pratt	Leaden Piper	Bag of marbles	A trumpet	A horse man
Alfred Harris	Tin Trumpeter	Bag of marbles	A trumpet	A drum
Maria Hazard	A tin woman	cups & saucers	A doll	Geese & keeper
Anne Davis	Tin chickens	A Doll	A village & plunder	A rabbit
Mary Humphreys		A village	A Doll	Geese & keeper
Priscilla Jones	Little bed & doll	A Doll	Cups & saucers	A doll
Harriet Harris	Cradle & bureau	A doll	A doll	Box of Sheep
Caroline Davis		A Doll	Man & donkey	Cups & saucers
Becky Posy	Chair & doll	Cups & saucers	A doll	Duck on her nest
Tom Milly	Tin coach	A drum	A trumpet	A village
George Humphreys		A trumpet	Tin toys	A horseman
Charly Buckingham		A Trumpet	Tin toys	A drum
Bill Matthews		Barn & sheep	Soldier & horse	A trumpet
Henry Jackson	A harmonica	Soldier on horse	A Drum	Wooden Rooster
Heloise Humphreys		A doll	A doll	Cups & saucers
Billy Davis		Soldier on horse	A trumpet	(Dead)
Mary Posy			A tin bed &	(Dead)
Sarah L. Hawkins		A trumpet	Old woman in a cradle	A doll
Josh Turner				A trumpet
Alick Milly				A horse man
E. Jane Humphreys				A doll
Daniel Toogood				A Lion

Alice Posy, my first protegée, in 1845, A flowered china cup.

Titled "Christmas Gifts of the Colored Children of Hampton given by E. Ridgely," this is the first page of a list of Christmas gifts given for the years 1841–1854 handwritten by Eliza (Didy) Ridgely (1828–1894), daughter of John and Eliza. Beside each name are such notations as the specific gift or the lack of one due to getting too old for a gift, bad behavior over the previous year, no longer living at Hampton, or in several cases death of the child.

Eliza (Didy) Ridgely White, later Buckler (1828–1894), daughter of John Carnan and Eliza Eichelberger Ridgely, is seen in this 1863–1864 image. Being well-schooled and -traveled, Eliza's diaries from the 1840s are a wonderful record of life during the early part of the 19th century, sharing tales of travels abroad, Christmas holidays and large house parties at Hampton, and the contrasts of living in the country and city.

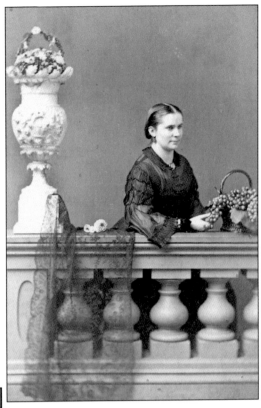

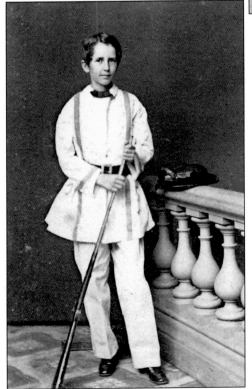

Henry White (1850–1927) was the oldest son of Eliza Ridgely White. He is shown wearing a white tunic and pants holding a long-muzzled rifle in this c. 1861 image. Henry White would grow up to have a very successful diplomatic career, including serving as U.S. ambassador to Italy (1905) and France (1907), as well as being a member of the American Commission to Negotiate Peace in 1918.

69

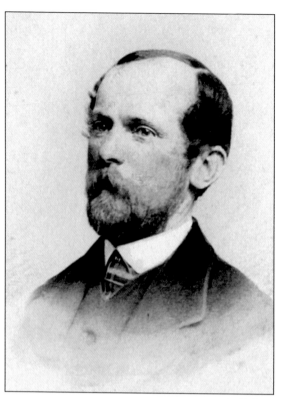

Images of Charles Ridgely (1830–1872), the fourth master of Hampton, and his wife, Margaretta Sophia Howard (1824–1904), are captured in these early-1860s *cartes de visite*. They were married in 1851 and thereafter assumed management of the Hampton estate. After the Civil War, the Ridgely family spent much of their time abroad, although they maintained close contact through detailed correspondence. Charles unexpectedly died in Italy of malarial fever, and Margaretta brought the family home. Margaretta, in keeping with Charles's will, remained as manager of the estate until her death, overseeing all financial aspects. She was also instrumental in maintaining the Jersey herd and continuing the involvement with Thoroughbred racing.

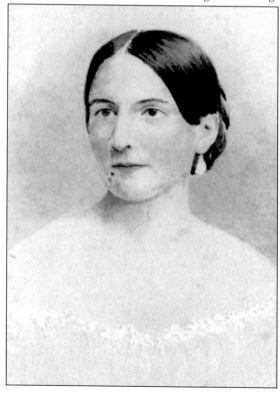

Dr. James McHenry Howard was a half-brother of Margaretta Howard Ridgely. Shown c. 1862–1863 in his gray Civil War uniform, he was a staff officer, assistant adjutant general of the Engineer Corps with the Confederate army.

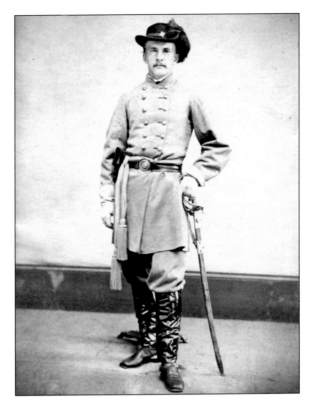

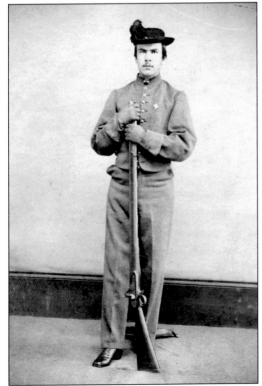

David Ridgely Howard, another half-brother of Margaretta H. Ridgely, is shown c. 1864 wearing his gray Civil War uniform and black hat with the plume of the Maryland Volunteers. He was a private in Company A, 2nd Maryland Infantry during the Civil War. Note the posture device in the background assisting David Ridgely Howard. This and the artistic placement of his rifle are the only visible indication that he lost his foot during the Battle of Gettysburg.

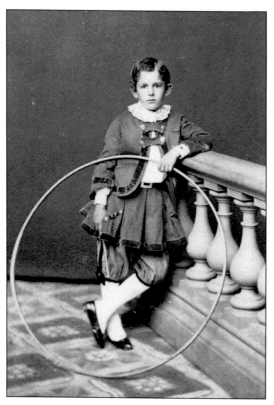

These two studio images are of the eldest sons of Charles and Margaretta Ridgely c. 1861–1862. The top image is of Charles Ridgely (1853–1873), the second son, who is shown in a child's suit of open jacket and skirt over knickers with white tights and black shoes. His white shirt has a lace collar on it. The bottom image is of John Ridgely (1851–1938), who was destined to become the next master of Hampton upon his father's death in 1872. He is shown in a soldier's jacket and long pants with a long muzzled rifle resting against the balustrade next to him. These images have similar inscriptions to the previous image of Henry White, and all three may have been done at the same time.

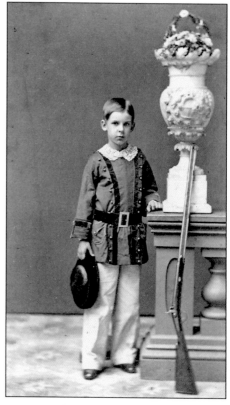

Eliza Ridgely (1858–1954), wearing a white dress, leans on the lap of Nancy Davis (died 1908), a beloved nursemaid and initially a slave, in this c. 1862 image. Nancy Davis holds a veil on her lap.

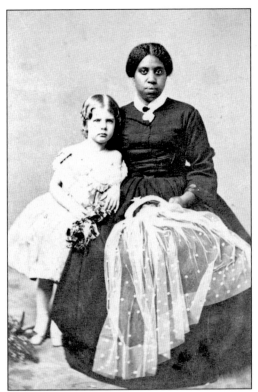

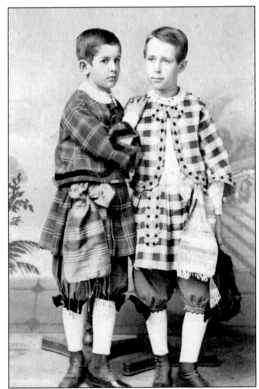

Two first cousins, Charles Ridgely (1853–1873) on the left and Julian White (1853–1923), are dressed in peasant costumes in this c. 1861–1862 image. Julian White is the younger son of Eliza (Didy) Ridgely and her first husband, John Campbell White.

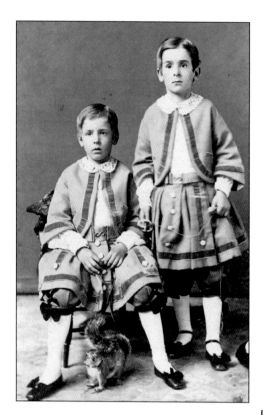

Howard (1855–1900) and Otho (1856–1929) Ridgely continue a theme of posing in peasant costumes in this c. 1861–1862 image. Note the squirrel on a leash in the foreground; the Ridgely children often had squirrels as pets.

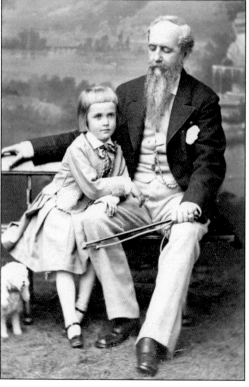

Dr. Thomas Buckler (1812–1901), Eliza (Didy) Ridgely's second husband, is seated with their son William Hepburn Buckler (1867–1953) for this studio photograph c. 1870. William Buckler graduated from law school, earning top honors for his thesis. His successful career as a diplomat included a posting as a staff member of the American Commission to Negotiate Peace in 1919. Classically trained, he participated in several major archaeological excavations in the early 20th century.

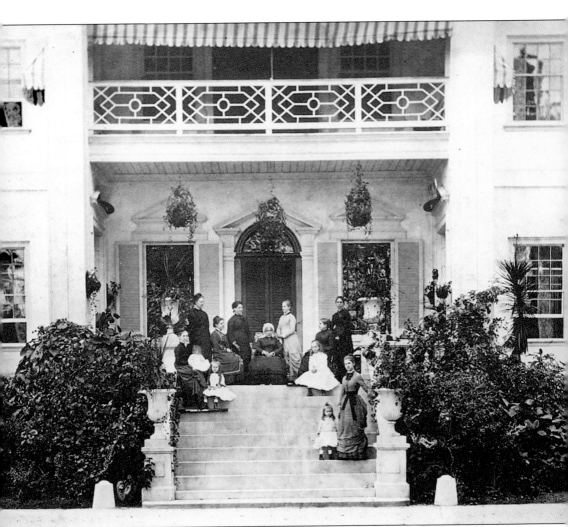

This fascinating c. 1878 photograph taken on the north portico of the mansion shows multiple generations of Ridgely women and relatives. Identified are, clockwise from left to right, Helen W. S. Ridgely (1854–1929) with daughter Margaret Ridgely (1876–1936) on her lap and daughter Leonice Ridgely next to her; Mary Post (1839–?), granddaughter of George and Prudence Ridgely Howard and daughter of Eugene and Margarette Elizabeth Howard Post; Eliza Ridgely (1858–1954); Sophia Norris (1820–1879), daughter of George and Prudence Ridgely Howard; Ellen Eichelberger (1795–1880), aunt of Eliza Eichelberger Ridgely; Juliana Ridgely (1862–1951), who later married John Southgate Yeaton; an unidentified child seated on the top step; Margaretta Sophia Ridgely (1824–1904); Elizabeth Myers; (on lower steps) an unidentified child; and Elise Milligan (1860–1937), daughter of George B. and Sophia Gough Carroll Milligan. Note the detailed lace curtains in all the windows and the use of a striped awning at the second-floor portico. Wooden horizontal-slat shutters are utilized on the front door to the mansion and its flanking windows.

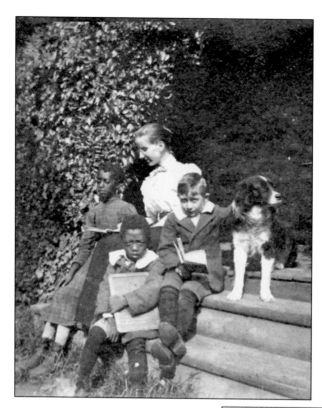

Margaretta S. Ridgely (1869–1949) sits on some steps teaching three unidentified children, two African American and one white, in this c. 1898 image. Never married, she instead dedicated her life to missionary work in Liberia after her mother's death in 1904.

This 1929 document is a one-year permit of residence granting Margaretta Ridgely the right to live in the Republic of Liberia. She spent 28 years there as a missionary, building a school for girls and teaching there until the age of 63. In honor of her dedicated service, the Liberian government named her a Knight Official of the Humane Order of African Redemption in 1927.

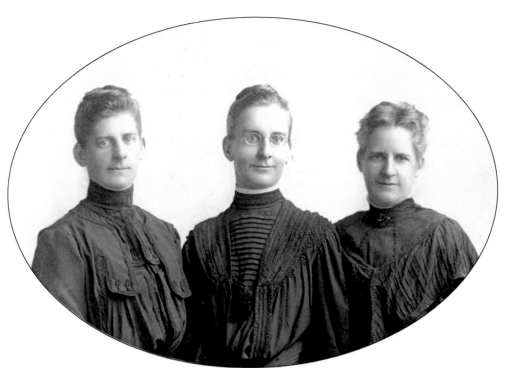

From left to right, Eliza Ridgely (1858–1954), Margaretta Ridgely (1869–1949), and Juliana Ridgely (1862–1951), who married J. Southgate Yeaton, are shown in this *c.* 1890 photograph. They were daughters of Charles and Margaretta Ridgely. The lower photograph, taken *c.* 1930 outside the east wing and hyphen of the mansion, shows the same three women. They are identified from left to right as Julia R. Yeaton, Eliza Ridgely, and Margaretta Ridgely.

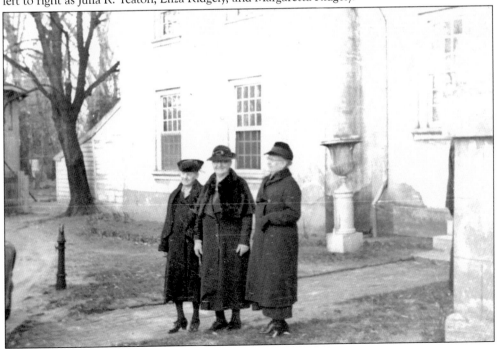

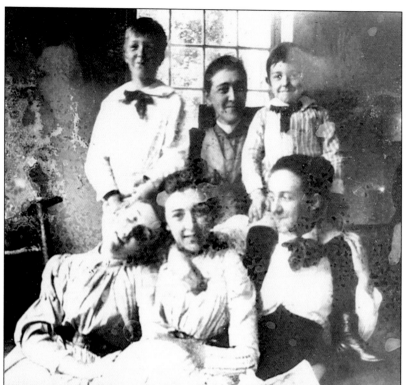

This is a family portrait of the John Ridgely (1851–1939) family c. 1892 on one of the mansion porticoes. Pictured from left to right are (first row) Helen (1877–1979), Margaret (1876–1936), and Leonice (1874–1934); (second row) David Stewart (1884–1978), Helen West Stewart (1854–1929), and Julian (1887–1939).

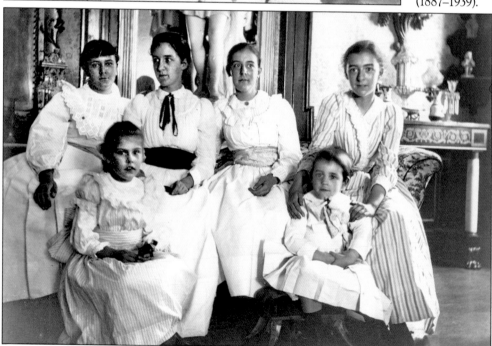

Posed in the drawing room of the mansion for this 1890 photograph are, from left to right, (first row) Margaret Yeaton (1885–1943) and Julian Ridgely (1887–1939); (second row) Claire Patterson, Helen Ridgely (1877–1979), Leonice Ridgely (1874–1934), and Margaret Ridgely (1876–1936).

This *c.* 1890 photograph shows Margaret Ridgely (1876–1936) kneeling behind Eliza Eichelberger Ridgely's harp in the music room. This image and another similar one were inspired by Eliza's portrait, *Lady with a Harp*.

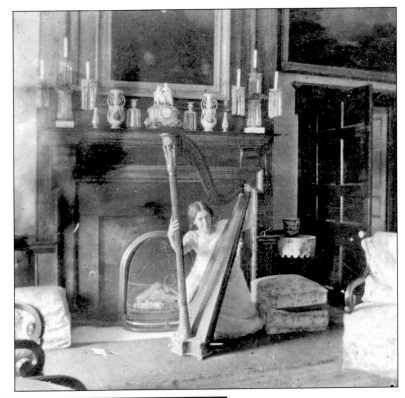

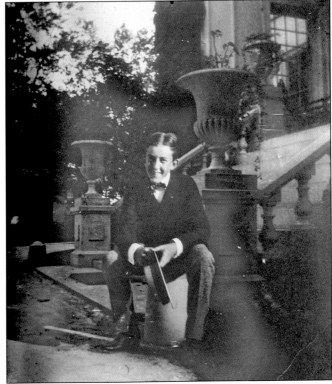

John Ridgely Jr. (1882–1959) sits on the steps of the north portico holding a boater hat in this milestone *c.* 1892 photograph. The photograph is inscribed "1st day in Long Trousers."

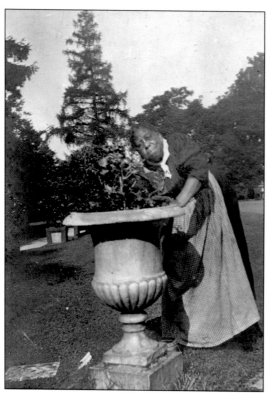

These two photographs of Mary, one of the black servants at Hampton, were taken almost 40 years apart (at left *c.* 1890 and below inscribed "Aug 1936"), attesting to her long years of service with the Ridgely family. A dedicated servant, she had many roles, including that of cook. In the lower photograph, she is standing in front of the octagon building that was used as servants' quarters.

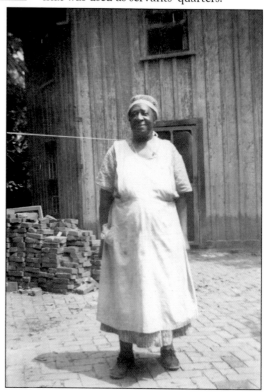

Nancy Davis, shown here standing on the steps of the west wing of the mansion c. 1895, was a former slave who remained with the Ridgely family as a servant after the Civil War. She was much loved, and when she passed away, she was given the honor of being buried in the family cemetery, one of only two non-family members to be so honored. The two other women are probably sisters Margaretta (1869–1949) and Juliana Ridgely (1862–1951).

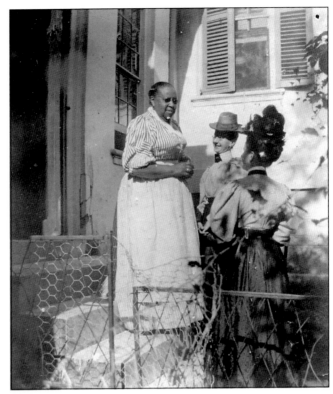

After the Civil War, Hampton's work force converted from slave labor to a mix of free African American laborers and white laborers. Seen c. 1897 is one of the many African American male servants needed to keep the property running. He is holding a wheelbarrow full of firewood in front of the east hyphen, on the brick walk running along the south side of the mansion.

These images capture the "boys of summer" Hampton-style in the late 1890s. In the top photograph, David Stewart Ridgely (1884–1978) holds a catcher's mask in his gloved left hand while John Ridgely Jr. (1882–1959) poses with a bat and ball. The lower photograph shows a game in progress with an unidentified building, possibly one of the stables, in the background.

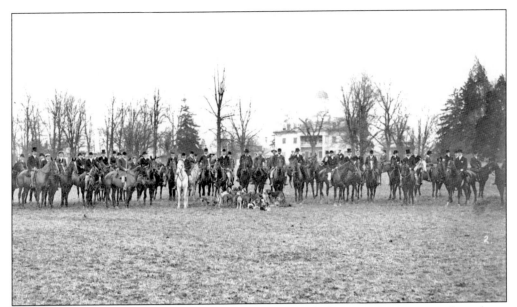

Gathered on the north lawn of the mansion ready for a foxhunt is a large group of people on horseback, probably a joint meeting of the Elkridge and Green Spring Hunt Clubs, including several women and 16 hounds, in this photograph dated February 2, 1909. Hunts were still an important part of the sporting scene at Hampton well into the 20th century. The mansion can be seen in the background.

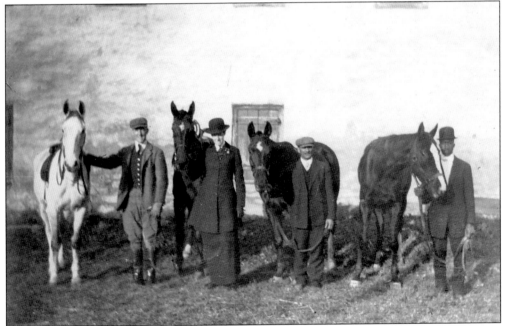

At far left, John Ridgely Jr. (1882–1959), the sixth master of Hampton, and his first wife, Louise Humrichouse (1883–1934), are seen in riding apparel with their horses in this photograph marked "Autumn 1912." The two men accompanying them are identified as Louis Davis (second from left) and Bryan, an African American groom or trainer. They stand in front of a large stone building, probably one of the stables adjacent to the north lawn.

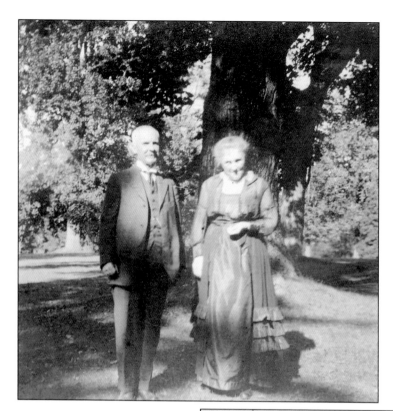

A "latter years" photograph of John Ridgely and his wife, Helen West Stewart Ridgely, was taken in their garden c. 1920.

This shipping list details the sale of Hampton's rare Madeira wine collection to J. Pierpont Morgan, Esq., by John Ridgely and is dated March 25, 1902. The proceeds from this sale provided the funds to install a radiator heat system, one of the only major improvements to the property during this time period. Electricity was not installed in the mansion until after Helen's death in 1929.

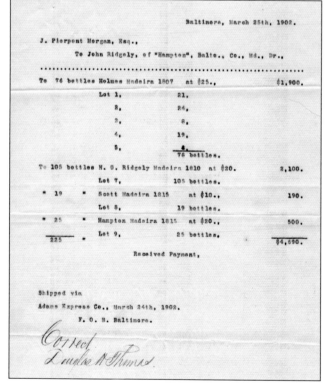

The President and Mrs. Roosevelt

request the pleasure of the company of

Mr. and Mrs. Ridgely

at a reception to be held at

The White House

Thursday evening, January the ninth

nineteen hundred and eight

from nine to half after ten o'clock

While the Ridgely family may have been struggling financially by this point in Hampton's history, they were still prominent socially and politically, as this document reflects. It is an invitation to Mr. and Mrs. John Ridgely for a reception at the White House given by President and Mrs. Roosevelt on January 9, 1908.

Seen *c.* 1895 writing at a small cloth-draped table, Helen West Stewart Ridgely (1854–1929) was the author of two books on Maryland history and architecture, a talented artist, and a commissioner for the Jamestown Exposition of 1907. Helen's typewriter can be seen in the background. She worked hard at her family and civic responsibilities, and many diary entries show the struggles she faced to help maintain the property and the Ridgelys' social status.

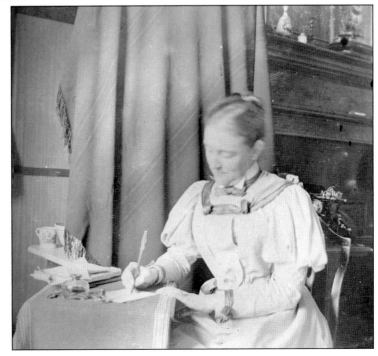

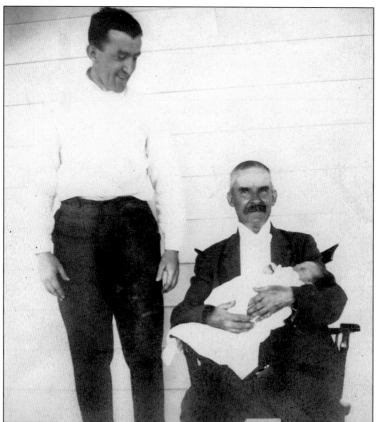

A classic multi-generational photograph is achieved in this image. John Ridgely (1851–1938) is seated holding his infant grandson John Ridgely III (1911–1990), while son John Ridgely Jr. (1882–1959) stands next to them looking down with a very happy expression.

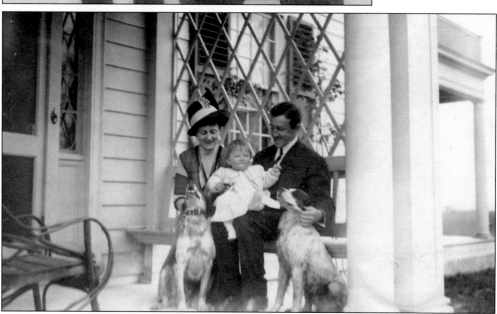

A c. 1912 portrait of the John Ridgely Jr. family shows John Ridgely III (1911–1990) balanced on his parents' laps while they each have one hand on him and one hand on one of the two family dogs.

Margaret Ridgely Leidy (1876–1936), daughter of John and Helen Ridgely, is seated on the mansion steps at Hampton holding her infant daughter, Helen West Leidy (1911–1969). Helen appears to be wearing a long christening gown. A curious dog stands on its hind legs, leaning in Margaret's lap to take a closer look.

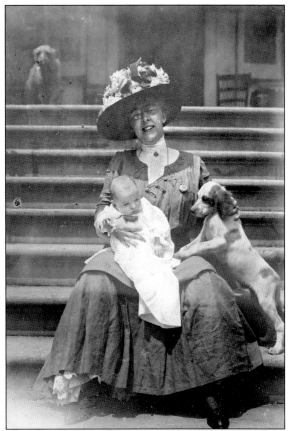

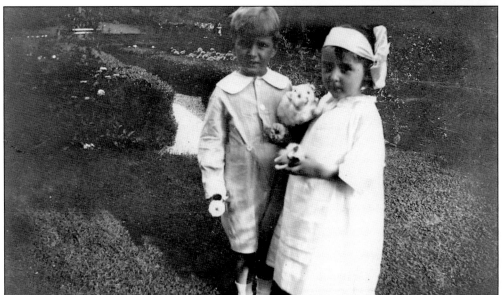

Cousins John Ridgely III (1911–1990) and Helen West Leidy (1911–1969) are seen in this sweet children's photograph dated 1914. He is holding flowers while she is holding two stuffed toy animals. The setting appears to be the formal gardens at Hampton.

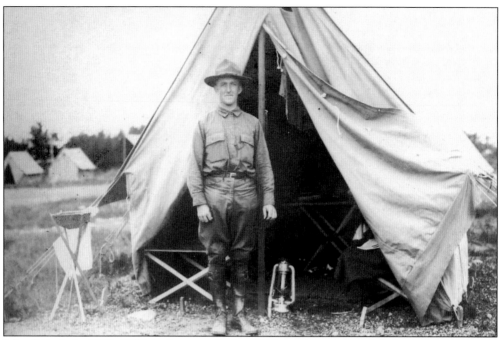

John Ridgely Jr. (1882–1959) is photographed in 1916 standing in front of a two-man tent in his army uniform. There is a wash basin to his left and a lantern set on the ground next to him.

This is a c. 1916 picture of James Walker Humrichouse Ridgely (1915–1976), the son of John and Louise Humrichouse Ridgely, standing next to what may be the family automobile. He is wearing the typical unisex toddler outfit of a dress and short socks with shoes.

This c. 1916 image captures a group of children playing on the south side of the mansion. The two children on the tricycles are probably Helen West Leidy (1911–1969) and John Ridgely III (1911–1990). The others are possibly other cousins sharing in the fun on a warm sunny day.

The ramp leading down to the terraced gardens is also well designed for sledding, as evidenced by the c. 1917 photograph of, from left to right, Sara Stewart (1904–1928), David Stewart Ridgely (1884–1978), and Julian White Ridgely (1887–1939).

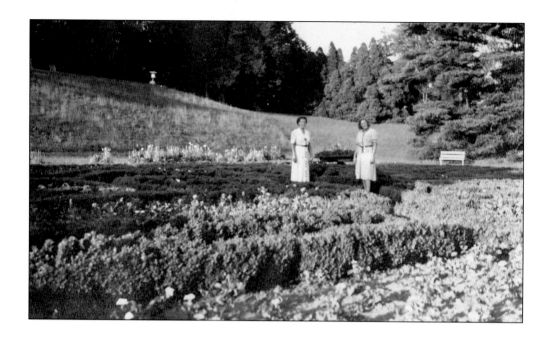

After her marriage to John Ridgely III, Lillian Ketchum Ridgely (1908–1996) initiated a garden restoration movement. It was her hope to bring back some of the terraced garden's former grandeur. Lillian and her mother, Anna Mae Higging Ketchum Field (1887–1947), stand in the formal gardens around 1940.

Capt. John Ridgely (1851–1938) and Anna Mae Field, Lillian's mother, stand outside the Long House/granary in this c. 1935 photograph.

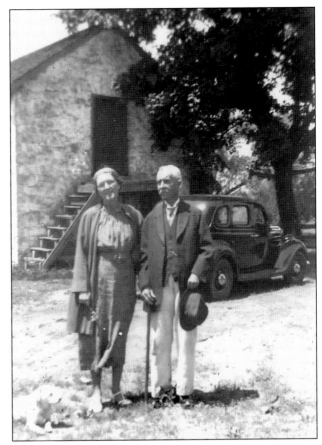

This 1941 photograph is inscribed "Walker Cleaning Packard June 1941." Walker is James Walker Humrichouse Ridgely (1915–1976), the younger brother of John Ridgely III. The octagon building in the background is no longer standing but was just east of the mansion.

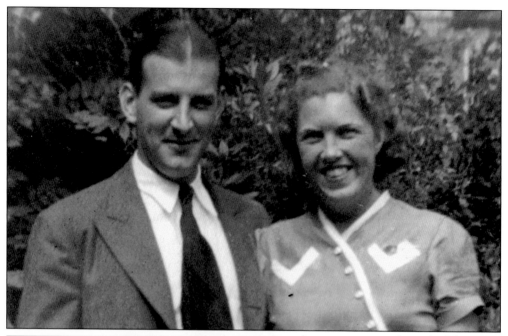

As a young married couple, John Ridgely III (1911–1990) and his wife Lillian Ketchum (1908–1996) lived for a short time with John's father and grandfather, becoming the last generation of Ridgelys to reside in the mansion. While John never attained the title of master of Hampton, he and his wife were critical to its management. World War II saw them serving their country, John as a soldier overseas and Lillian as an army nurse.

Taddy seems to make his appearance in many of Lillian Ridgely's photographs around 1940. Each generation of the Ridgely family had their collection of beloved pets. Some were traditional ones such as dogs and cats, others not so—including a snake.

Four

THE HOME FARM

The home farm as it exists today is a 14-plus-acre remnant that represents the core of the home farm that once supported Hampton mansion. Hampton at its height had a number of these contained farm properties, each serving a specific purpose in support of the overall estate. Many original buildings were lost as the Ridgelys developed the land around the home farm, and others fell into disuse and disrepair. Nine surviving structures—the Farm House, two stone slave quarters, a log building, a dairy, an ash house, a garage (originally a dovecote), a mule barn, and the Long House/granary—retain a great deal of integrity and allow the story of this part of the property to be interpreted.

Dating from the early 18th century, the oldest sections of the Farm House were probably already on the site when the Ridgelys purchased the property in 1745. They expanded the structure, adding a wing and connector in the 19th century and a final wing in the late 1940s to provide for modern conveniences. The house also underwent several interior renovations, the addition of a belfry, and varying porch configurations during its three centuries.

Apart from the Farm House, the earliest building on the farm property that remains intact is the dairy, constructed by 1800. Most of the remaining farm buildings seen today were constructed in a mid-19th-century rebuilding campaign that replaced earlier structures. Based on the aesthetic theory of *ferme ornée*, these structures were carefully sited and designed to give the feeling of a picturesque village setting. Built at this time, the mule barn, two of the slave quarters, and the Long House/granary are well-crafted vernacular stone structures. While the use of stone is in keeping with many regional buildings of the time period, its use on buildings of these types and the addition of purely decorative wooden detailing such as the bargeboards attests to the wealth of the Ridgely family and their intent to make an impression on their visitors.

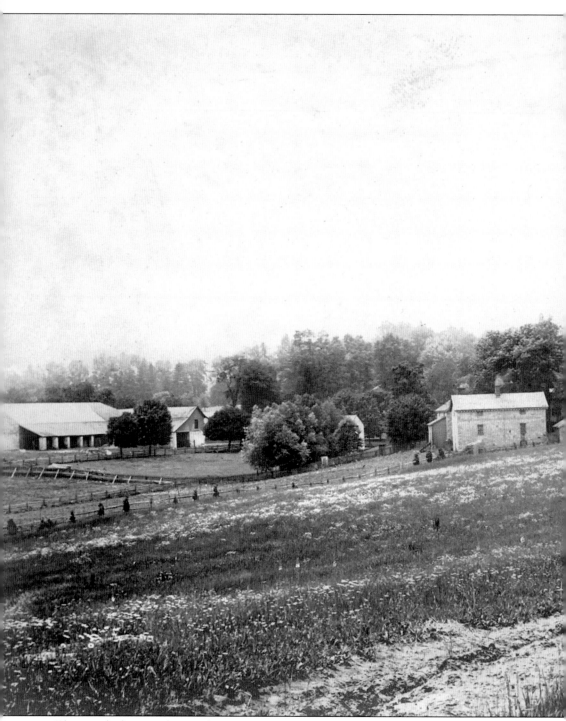

This vista looking south around 1906 shows the core of the home farm. At the left of the photograph, the large cow barn, no longer extant, can be seen. The next cluster of buildings includes the stone quarters, the ash house, and the log building. The final grouping at the right shows the dovecote,

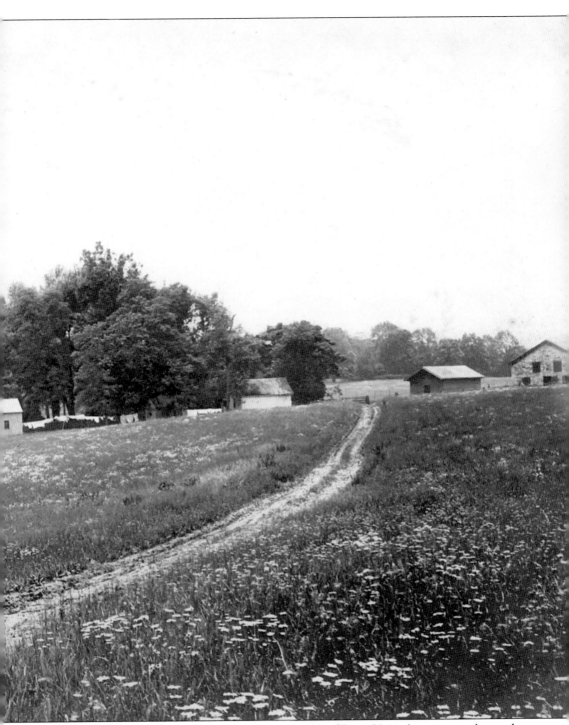

the corncrib, and the mule barn. Views of the Farm House and Long House/granary are obscured by the foliage. Note the fencing and dirt path, which no longer exist on the site today.

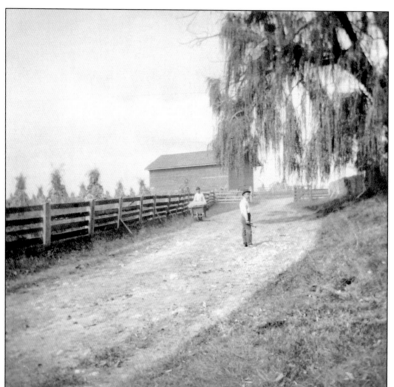

A c. 1897 view of the home farm at Hampton looks down what is today referred to as the Farm Road. Corn is visible in the field behind the fence along the left of the dirt path, and the corncrib is visible beyond a gate in the distance. Two workers are seen, one with hand tools and the other with a loaded wheelbarrow, as they tend to their jobs.

This modern image is of the corncrib just before it was destroyed in an arson fire in the 1980s. Notice the architectural detailing along the eaves and gable end, which match that on the stone buildings constructed c. 1845. The use of wood for the construction of this structure allowed for it to protect the corn from most environmental elements while still providing needed ventilation.

Three unidentified children are seen at the steps of the Long House/ granary in this c. 1895 photograph. Part of a field fence and a dirt path can be seen in the background.

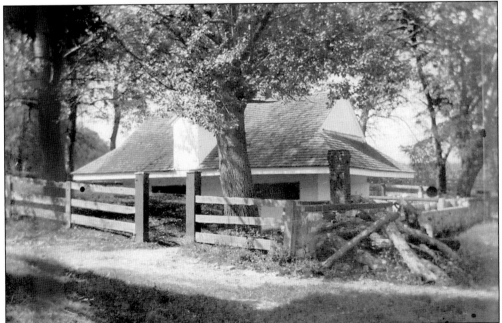

A c. 1892 view of the dairy shows it encircled with a wooden fence. Notice the wood pile in the front right corner. It was possibly stacked there for use in the sterilizing oven just beyond, marked by the short brick chimney. The dairy was in constant use from the late 18th century through the early 20th century, providing dairy products initially for the mansion's use and later for sale.

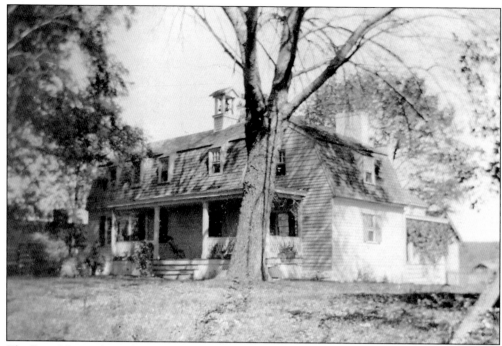

The Farm House, shown here c. 1895, was the residence of the Ridgelys' farm manager or overseer for most of its history. The top view is taken from the southwest showing the elevation fronting on a large grassy meadow. The front door and covered porch are visible, with just a piece of the rear porch showing. The lower photograph shows this rear porch in a view taken from a more southerly direction. A picket fence can be seen in the middle ground and would have provided a bit of separation.

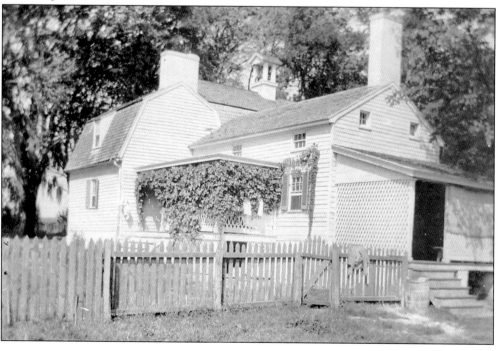

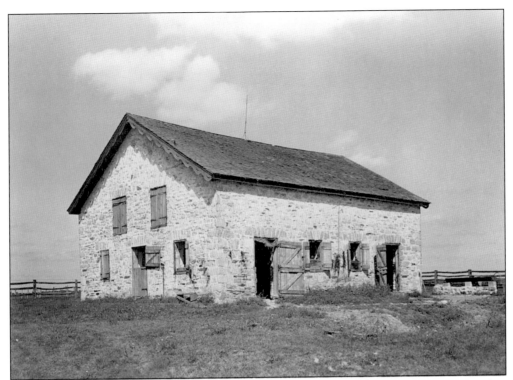

The mule barn, seen here in 1936, was originally constructed *c.* 1845 during a major construction campaign. It is a stone structure with symmetrical window and door opening pattern and decorative wooden bargeboard detailing. A split-rail fence can be seen beyond the building.

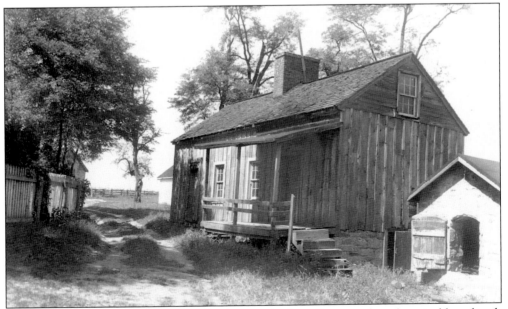

The log building known as Quarters No. 1 retains its large front porch and vertical board-and-batten siding in this *c.* 1915 photograph. The small gabled stone building in the lower right corner is one of at least two ash houses originally located around the quarters.

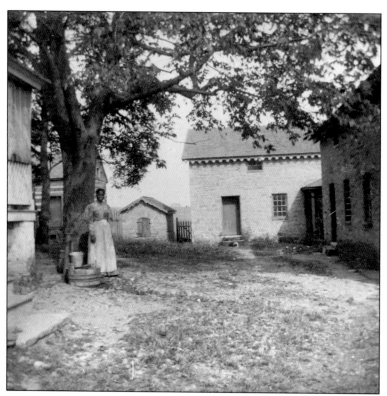

In this c. 1897 photograph, portions of both stone quarters are visible as well as one of the ash houses with its door closed. The back porch of the farmhouse is just visible along the left side of the image. An unidentified African American woman stands under a tree to the left of a small metal bucket and large wood tub as if caught in the midst of her cleaning work.

This is a handwritten reward notice offered by Charles Carnan Ridgely on April 20, 1791, for the return of a runaway slave named Bateman. The document gives a physical description of Bateman and the clothes he was wearing when he left. Interestingly the reward varies, increasing as the distance from Hampton he is found increases.

Charles Carnan Ridgely provided for the freeing of many of his slaves in his will. The terms included that once a female slave reached the age of 25, she would be allowed her freedom. This certificate is a legal document issued by the Register of Wills in Baltimore City freeing the female slave Polly and is dated July 1860.

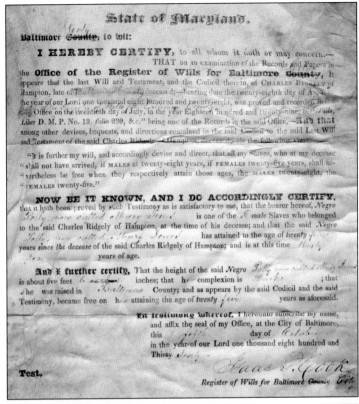

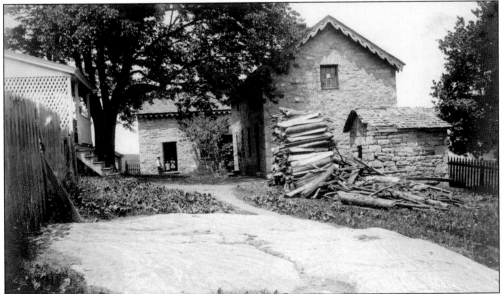

This image shows the domestic cluster formed by the quarters to the right and background and the farmhouse on the left around 1900. A second ash house with a large woodpile next to it is visible in the foreground. Ash was one of the main ingredients used in making soap. Three African American children can be seen in the quarters, which were used for tenant farmers and other paid laborers after the Civil War.

A handwritten document dated 1858 lists the lineage of cattle at Hampton with a beginning date of May 3, 1858. It lists identifying features of the calves and gives what look like registration numbers. Interestingly this was found in a softbound notebook inscribed "Church Fund / of Trinity Church / Towsontown" on its inside cover.

This is one of two newspaper articles dating from 1881 discussing the dairy cows bred at Hampton. Both articles extol the quantity and quality of milk produced by the herd and its offspring, emphasizing their value.

A Valuable Milch Cow.—Thomas M. Wolfe, Esq., of this city, is the owner of one of the finest cows in this vicinity. She is of what is known as the Jersey or Alderney breed of cows, and was purchased by Mr. Wolfe from the celebrated herd of Jno. Ridgley, Esq., of Hampton. Her pedigree is as follows: Ragweed, bred by John Ridgley, Esq., of Hampton, No. 4502, American Jersey Herd Book, calendared October 16th, 1874, sire Orange Peel, No. 864, A. J. H. B., imported by C. Ridgley, of Hampton, dam Horse Shoe, No. 1260, A. J. H. B. A recent experiment of the butter producing qualities of this cow made by Mr. Wolf shows that this valuable animal produced 14½ pounds of butter in one week. In that time she gave in two milkings each day upon an average, nearly 4¼ gallons of milk per day, which produced 4¼ gallons of cream a week, weighing 44 pounds. At the time of the trial Ragweed was fed upon dry feed. It is estimated by competent judges that when in pasture she will have to be milked three times a day, and will produce at least twenty pounds of butter a week. Ragweed is the dam of four heifer calves.

The Ridgely herd for a time period in the early 1880s is documented in this 10-page booklet. It includes a foldout chart of the blood/breeding lines of King Rex, 5428, followed by printed pages with names of the Hampton herd and their birthdates, a brief description, and names of the dam and sire. "J. R. of H. desk" is written on the cover, identifying this as the working master inventory.

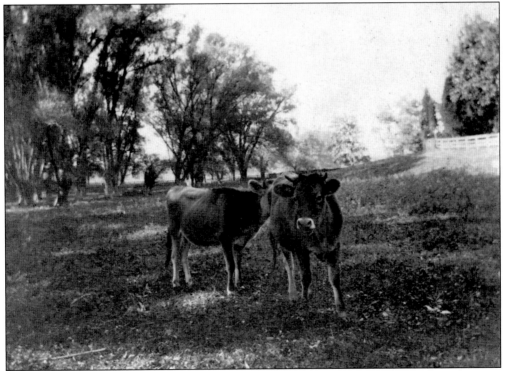

A c. 1897 photograph shows a few cows of the Ridgely Jersey herd out in the pasture fields.

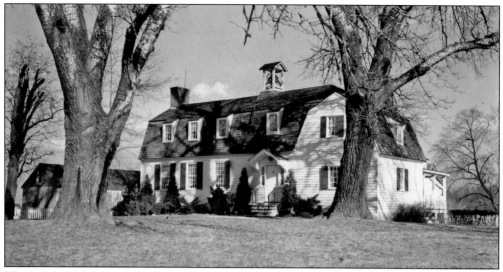

This image of the Farm House dates to c. 1940. Note there is no longer an extended front porch covering the front door but rather just a decorative overhang right above the door to provide a minimal shelter from the weather.

The dairy remains virtually unchanged in this c. 1930 image, compared to earlier images. The most noticeable change is the removal of the wood fencing that once surrounded it. It continued to operate as a dairy, providing the Ridgelys with a source of income and a number of workers with steady employment, such as the dairyman shown here.

Five

HAMPTON NATIONAL HISTORIC SITE

The beginning idea for the establishment of Hampton National Historic Site can be traced to a 1945 meeting of John Ridgely Jr. and David Finley, the director of the National Gallery of Art. Mr. Finley was at Hampton to examine Thomas Sully's portrait of Eliza Ridgely, *The Lady with the Harp*, and in conversation was made aware of the concerns over Hampton's future. Upon return to Washington, Mr. Finley contacted a number of individuals, including Ailsa Mellon Bruce and Donald Shepard from the Mellon family's Avalon Foundation; Fiske Kimball, a member of the National Park Service Advisory Board; and Ronald Lee, chief historian of the National Park Service, to raise interest in the preservation of Hampton, seen as a nationally significant property based on its "outstanding merit as an architectural monument." The discussion revolved around how best to preserve the property. After lengthy negotiations, it was decided that the Avalon Foundation would purchase Hampton mansion and donate it to the park service with the condition that there be a custodial organization in place to manage the site.

The initial Avalon Foundation funds allowed for the acquisition of the mansion, some of its furnishings, and 43-plus acres of land. The Society for the Preservation of Maryland Antiquities (SPMA, now Preservation Maryland) was named the custodial organization. The cooperating agreement was signed by Pres. Harry Truman on October 6, 1947, and Hampton was officially designated a National Historic Site by the secretary of the interior on June 22, 1948. The Avalon Foundation gave additional funds for repairs and landscape preservation work. Once this work was complete, Hampton National Historic Site was officially opened to the public on May 2, 1949.

The SPMA continued to manage the site, interpreting it to the period of Governor Ridgely (1760–1829), until October 1979, when the park service assumed full administrative responsibility for the site, a role it maintains today. Additional acreage with existing historic buildings has been added to the original piece of property, bringing the current size of the park to approximately 63 acres. The National Park Service has also done extensive research, creating a detailed interpretive plan that allows for the stories of all major time periods of the mansion to be told through meticulously restored period rooms.

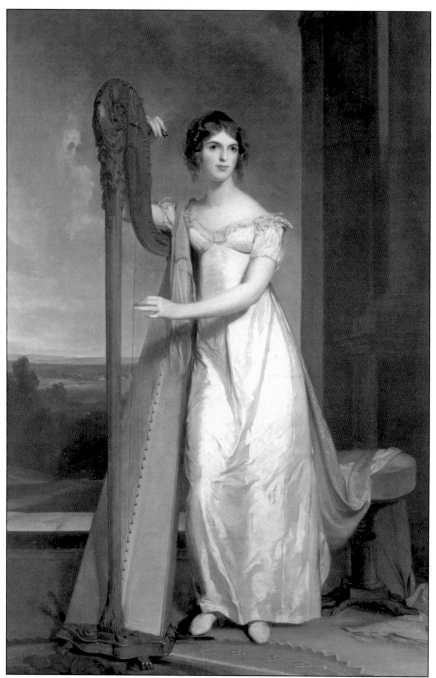

Thomas Sully, regarded as America's leading portrait artist of the time, painted *Lady with a Harp* depicting Eliza Eichelberger Ridgely in 1818, when she was 15 years old. The portrait hung in a prominent location in the great hall from the time she became the mistress of Hampton in 1829 until the mansion became part of the National Historic Site. Little did anyone know at the time the important role this painting would have in literally saving Hampton. (Thomas Sully, *Lady with a Harp: Eliza Ridgely*, gift of Maude Monell Vetiesen, Image © 2007 Board of Trustees, National Gallery of Art, Washington.)

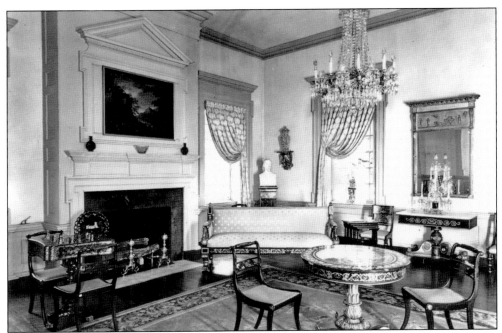

These *c.* 1955 photographs of the drawing room (above) and the music room (below) show the rooms' appearances during the administration of the SPMA. Their intent was to furnish the rooms to the time period right after the mansion was constructed. Ridgely items original to the house are blended with gifts and loans from private collectors and such organizations as the Maryland Historical Society and the Baltimore Museum of Art. Eliza Ridgely's harp can be seen in the music room. The suite of painted furniture in the drawing room was specifically made for this room by John Finlay in 1832. Scalamandré Silks provided the material for the curtains in all the first-floor rooms. The Colonial Dames of America, Maryland Chapter 1, furnished and maintained the music room, a relationship that continues today with the parlor.

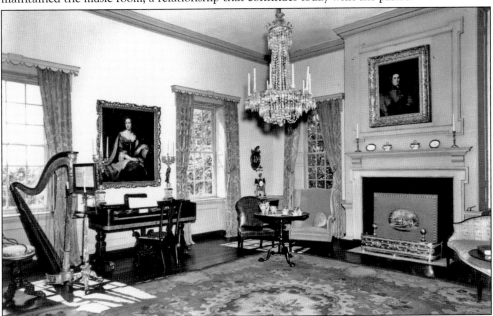

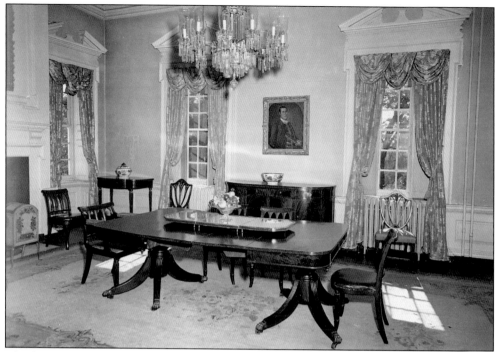

The dining room (above) and the great hall (below) are shown *c.* 1955. The southeast room on the first floor is once again furnished as a dining room, in keeping with its original use. Scalamandré Silks curtains adorn the windows in this tastefully furnished room. The view of the great hall looks south toward the garden-side entrance. The chandelier in the foreground is one of a pair of Waterford chandeliers given to Hampton National Historic Site by Ailsa Mellon Bruce.

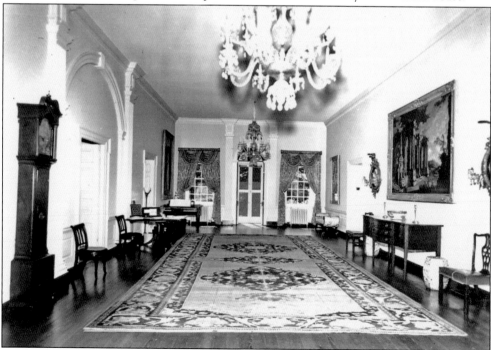

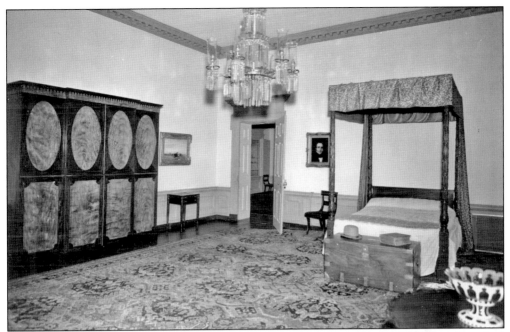

This is the northwest bedchamber or master bedchamber as furnished c. 1955. It is furnished in period furniture, both Ridgely and non-Ridgely pieces. At this time, much of the original furniture was no longer with the house, having been inherited by other family members or disbursed through sales.

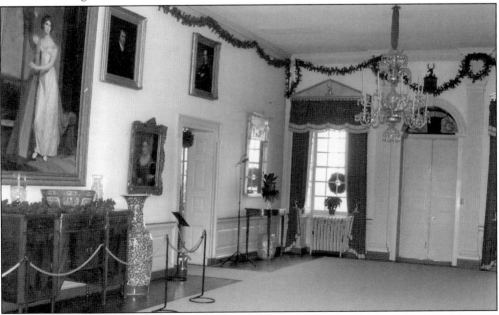

Compare this photograph of the great hall (2003) to both the c. 1955 photograph and historic photographs, and the reinterpretation of the house becomes evident. The great hall once again has many generations of family portraits, as it did historically, including the copy portrait (c. 1950) of Lady with a Harp by Gregory Stapko, a foremost copyist of famous works of art. One of the large Chinese export jars purchased by Eliza Ridgely can also be seen.

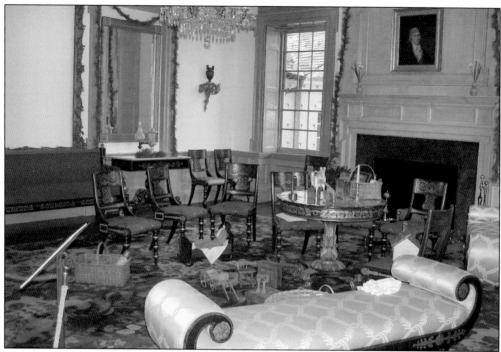

Decorated for Yuletide, the drawing room is being restored to its 1830–1850 appearance. With toys scattered on the floor and on the table, these photographs depict a scene in the mid-19th century, when the children of the Ridgely family gave toys to the slave children at Christmas. The painted furniture (1832) was ordered specifically for this room at the shop of John Finlay, who was considered the most prominent "fancy" furniture maker of his time in Baltimore. The English "tapestry velvet" carpet dates to 1850. A portrait of Nicholas Greenbury Ridgely, Eliza's father, hangs above the mantel.

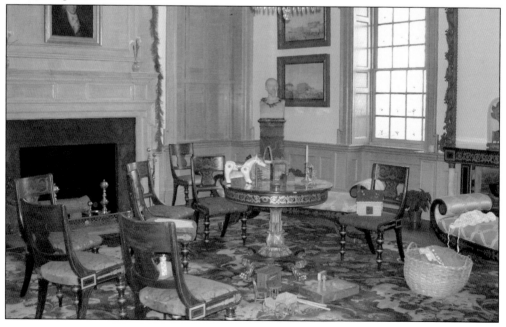

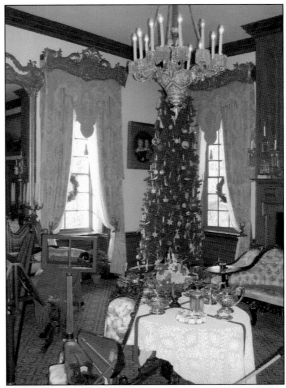

The music room, here shown at Yuletide, is interpreted to the 1870–1890 Victorian period. It is awash in colors, textures, and patterns. The tree is located in the corner where the Ridgely family placed their red cedar Christmas tree. The woodwork is grained to give the appearance of walnut, and the walls are wallpapered in a tone-on-tone pattern. The window treatments include reproduction curtain valances copied from surviving originals, and the large original elaborately carved and gilded wood cornices are decorated with the Ridgely family crest, the stag's head. The matching pier mirror, dated 1851, can be seen on the left edge of the top photograph. The chandelier was originally purchased by Eliza Ridgely for this room. Two of the family's musical instruments can be seen: Eliza's harp and an 1878 Steinway piano.

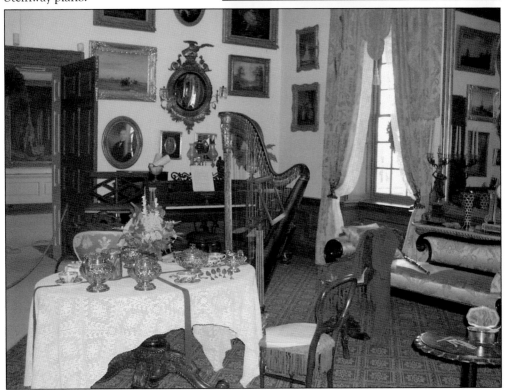

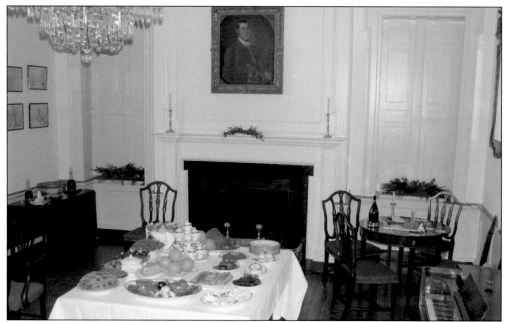

The Colonial Dames of America, Maryland Chapter 1, has provided assistance in furnishing the parlor, seen set up for a supper party at Yuletide. Further research is ongoing to bring this room to its historic 1790–1810 appearance. A portrait of Capt. Charles Ridgely (1733–1790) hangs above the mantel in the top photograph. The lower photograph shows a portrait of his wife, Rebecca Dorsey (1739–1812). The table in the foreground shows holiday fare from this time period, while the table in the background is set up for card games such as whist. The c. 1790 shield-back chairs in the Baltimore Federal style seen in the photographs are Ridgely originals used at the mansion until they were sold in the 1930s. Through the generosity of a member of the Colonial Dames, they have been reunited with the mansion.

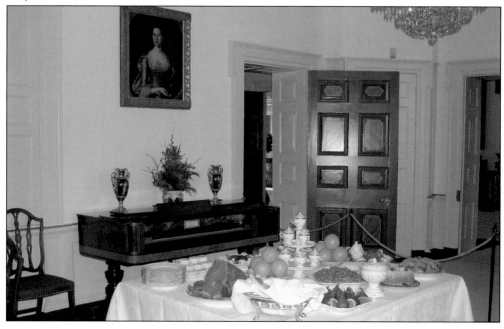

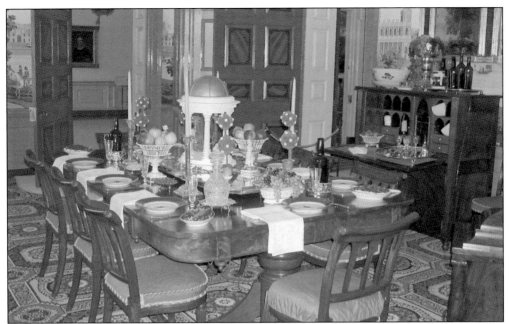

The dining room, with its vivid Prussian blue woodwork and matching blue-and-yellow window hangings, has been restored to the 1810–1829 period. The silk draperies are based on a plate from a period French design book by Pierre de la Mesangere, once owned by the Ridgelys. This room has scenic French wallpaper named "Monuments of Paris," originally manufactured by Dufour. The table is set for dessert with an elaborate decorative plateau display in the center. A cellarette (or wine cooler) in the shape of a small temple is seen on the floor in the lower photograph. The fall-front secretary was probably made by William Camp, a leading cabinetmaker in Baltimore during this time. The reproduction carpet is a Brussels type of neoclassical design. It is an opulent but sophisticated room reflecting Governor Ridgely's reputation for keeping the "best table in America."

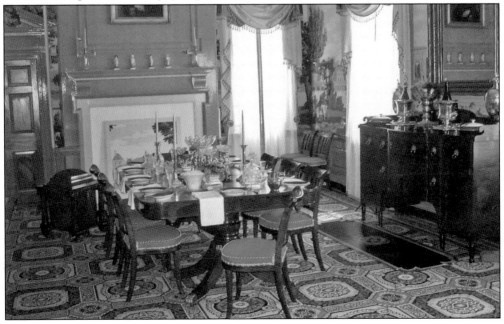

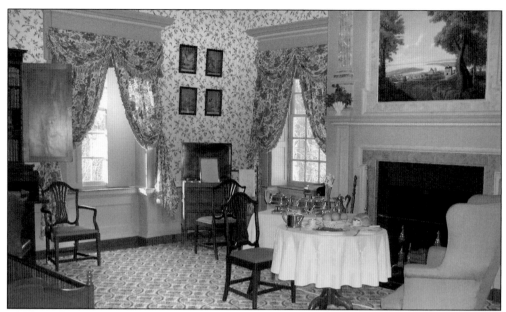

The northwest chamber or master bedchamber has been restored to its 1790–1810 appearance. The floral wallpaper is a reproduction of a *c.* 1792 floral trail print popular at the time. The Brussels carpet, copying a 1790s design, was woven in England specifically for this room. The top photograph shows the room set up for breakfast. In the background is an English gentlemen's dressing table. The bottom photograph highlights a recent acquisition, Governor Ridgely's original Federal tall-post bed. No longer in family ownership when Hampton became a historic site, it was purchased at auction in 2002 with funds raised by Historic Hampton, Inc., and returned to the mansion. The blue hand-stitched tambour embroidery-on-muslin bed hangings, made in France, reproduce the historic summer hangings for this bed. A telescope, a historic Ridgely piece, can be seen just at the lower right edge sitting on the table.

The northeast bedchamber is currently being interpreted as a children's bedroom, as public visitors are not allowed on the third floor, where most of the children's bedrooms usually were. Children's toys and books are seen placed around the room. The maple bed was made by John Needles, a Baltimore Quaker cabinetmaker, in the 1820s or 1830s. The ornate cast-iron stove set in the fireplace dates from 1847 and was ordered specifically for this room. The mantel in this room is much more elaborately carved that those on the first floor. The carpet is a Turkey carpet purchased in the late 1850s.

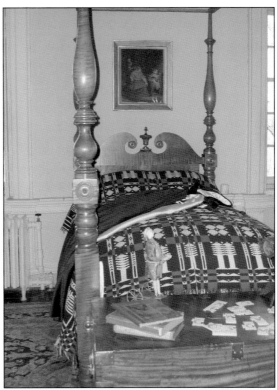

Although the historic entrance drive and carriage drives date from the construction of the mansion, no formal entry existed until almost 100 years later. This formally designed entrance was constructed between 1875 and 1880. The entrance structure was designed by John C. E. Laing to include a wide central pair of gates for vehicles flanked by narrower gates providing pedestrian access, ending in low, curved, cast-iron fences. The gate posts and base of the fences are constructed from ashlar white granite. The original drawings for the entrance are part of the Hampton National Historic Site archives. Note the incorporation of a stag's head, the Ridgely family crest, in the design of the gates. (Above photograph by Sally Sims Stokes, 2003; photograph at left by Ann Milkovich McKee, 2007.)

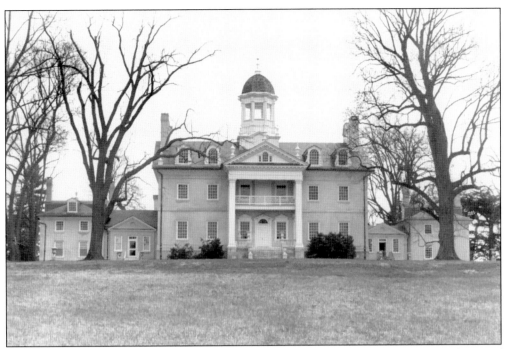

Hampton mansion today still sits as an imposing example of the late Georgian style, a legacy of many generations of the Ridgely family and those who served them. The exterior of the mansion has seen minimal changes since becoming a National Historic Site. An early wooden lean-to summer kitchen on the east end of the mansion was demolished in 1950. Public access has been added to the two hyphens on the north facade (above) to accommodate tour groups. Other restoration and cyclical maintenance projects are ongoing. (Photographs by Sally Sims Stokes, 2003.)

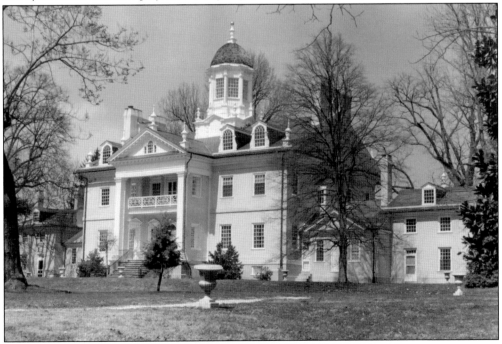

While Hampton originally had several ice houses, this is the only remaining one. Constructed concurrently with the mansion out of the same stone, the bottom of the ice well reaches approximately 34 feet deep. A brick dome cap on the well supports earth and sod, creating the aboveground mound. The north entrance provides a hatchway to lower in large blocks of ice; the south entrance provides access via marble stairs for servants to retrieve ice. (Photograph by Sally Sims Stokes, 2003.)

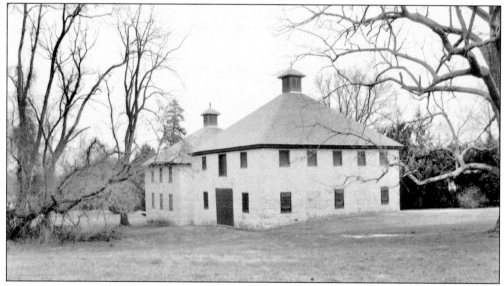

Thoroughbred racing and breeding were the passions of several generations of Ridgelys. These stables housed prize horses and the stable hands and jockeys that worked with them. Both are stone with pyramidal hipped roofs. Stable No. 1 (foreground) was constructed between 1798 and 1805 and was finished with scored stucco to match the mansion. Stable No. 2, built c. 1855, was finished with exposed stone. Cupolas have been reproduced using an existing original as a pattern and were replaced on both stables in 2003. (Photograph by Ann Milkovich McKee, 2007.)

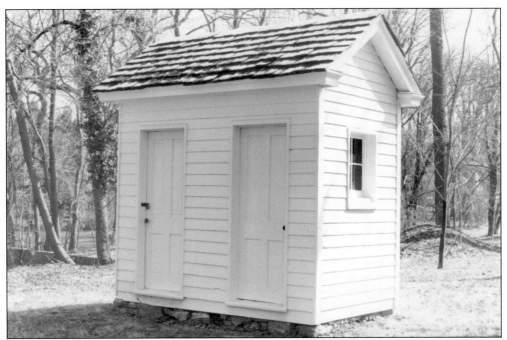

These two buildings are representative of the outbuildings found clustered off the east end of the mansion. While the top photograph depicts a *c.* 1800 privy and the bottom photograph an 1890s pump house, there are also several other buildings from the *c.* 1800 time period still extant, including a paint house, another privy, and a smokehouse. A *c.* 1910 garage stands off to the side of the grouping. The privy shown is a four-hole privy, with the central ones built on a higher bench than the outer ones. There is a wooden vertical partition dividing the interior into two sections and providing a bit of privacy. The pump house originally housed the pumps and other machinery as part of the waterworks for moving water from springs on the east side of the property to the mansion. (Photographs by Sally Sims Stokes, 2003.)

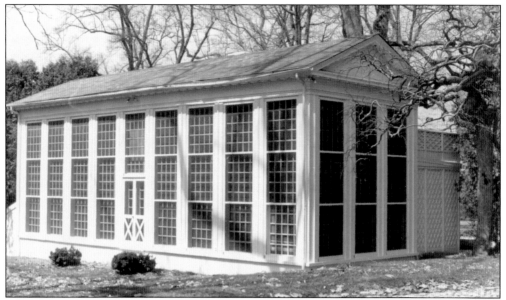

Although the c. 1824 orangery burned in 1926, historic documentation allowed an accurate reconstruction to be completed in 1976 on the original foundations. The foundations are rubble-stone masonry, which was originally whitewashed, as were the north and west walls. The one-story wood structure is designed to look like a Grecian temple. Its south and east walls are mostly full-height, triple-hung windows to take advantage of the best natural light for growing citrus plants. (Photograph by Sally Sims Stokes, 2003.)

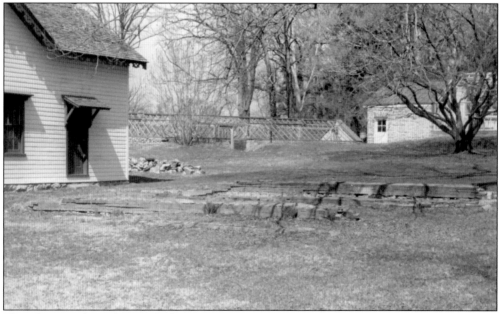

This photograph is taken in the heart of the garden maintenance area. To the left is the garden maintenance building originally used to store garden machinery, vehicles, and work animals. In the foreground are ruins of two cold frames originally used to jump-start plants, especially vegetables, in the spring. The two extant greenhouses, in disrepair, can be seen in the background. (Photograph by Sally Sims Stokes, 2003.)

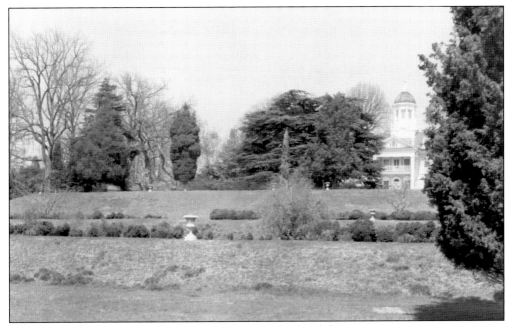

Standing at the lower end of the garden, the magnitude of the terrace construction project is easily discerned. It is said to have been one of the largest earth-moving projects of the 18th century—all for a pleasure garden. Today, while the terraces are still intact, the plantings are a mixture of types. It is hoped that one day the gardens can be restored to their full grandeur. (Photograph by Sally Sims Stokes, 2003.)

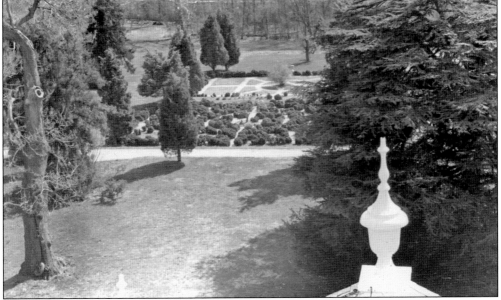

This is a modern view of the garden taken from the cupola. Parterres No. 1, 3, and 5 are visible to the left of the cedar of Lebanon planted by Eliza Ridgely in the mid-19th century. Parterre No. 1, on the first terrace below the Great Terrace, is the only one to maintain the use of boxwood borders, gravel paths, and plantings from the c. 1800 period of garden design. (Photograph by Sally Sims Stokes, 2003.)

This view shows the residential cluster of buildings on the home farm. Slave Quarters No. 2 (the stone building at the left) and the log farm structure in the center show how both buildings take advantage of the grade to provide at least a partial basement exposed on two sides. A small stone ash house can be seen between these two buildings. The Farm House is visible on the right, framed by a white picket fence. (Photograph by Sally Sims Stokes, 2003.)

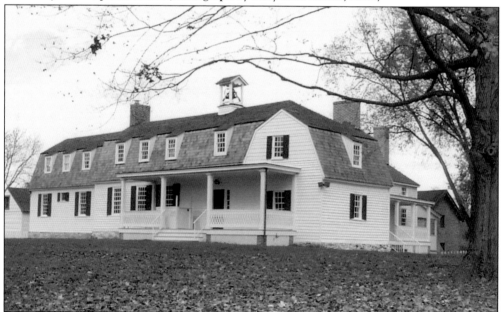

The c. 1948 addition is at the east end (the left in the photograph) of the Farm House and is slightly set back from the historic portion in this 2003 photograph. The recently restored front porch is also visible and was based on historic photographic documentation and archaeological work. Today the Farm House is beginning to be utilized more completely, as the story of the home farm plays a larger role in the overall site interpretive plan.

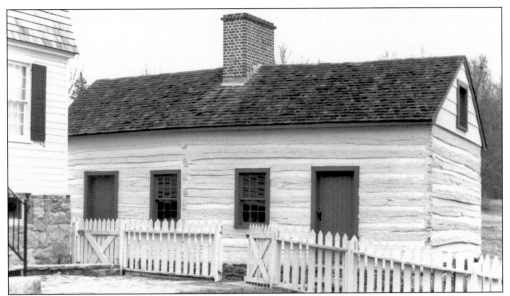

The c. 1835–1869 log farm structure referred to as Slave Quarters No. 1 is one of the buildings used heavily for interpretation at the home farm. It retains its two-room configuration on each floor and has a partial basement on one side. Earlier pictures show it having vertical board siding and a large porch spanning the front elevation. Recent studies question its use as a residential building, but no conclusive evidence has been found. (Photograph by Sally Sims Stokes, 2003.)

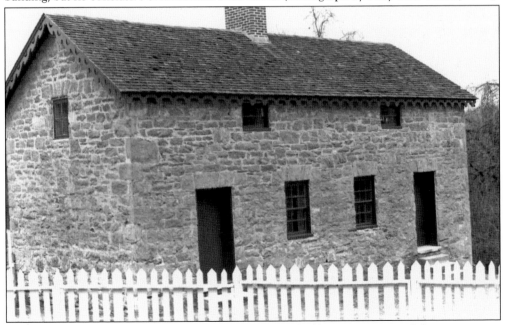

These stone quarters, built c. 1845, maintain a high level of historic integrity. It has a two-room configuration on each floor divided by a central fireplace and wood partitions. With its well-crafted stone construction and decorative architectural detailing, this building and Quarters No. 3 figure prominently in the overall *ferme ornée* design. Further interpretive plans are underway to develop exhibits in these buildings showing the residential quarters for slaves and tenant farmers on the Ridgely estate. (Photograph by Sally Sims Stokes, 2003.)

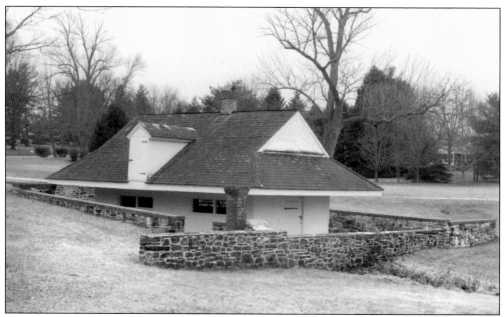

The dairy still stands, with its surrounding brick terrace, retaining walls, and sterilizing oven fairly intact. It is sited over a spring that continues to run through the building, spilling out to a small creek beyond on the eastern side of the dairy. It remains one of the showplaces on the estate given its large size, unique siting, and c. 1800 construction date. (Photograph by Sally Sims Stokes, 2003.)

This building was originally used as a hog barn and granary and when built was across from the enormous cow barn that was demolished in 1969. Animals were housed on the ground level with feed storage above. It was constructed around 1845 as part of the cluster of farm buildings creating the picturesque setting. Constructed out of ashlar stone, it had a wood roof and decorative bargeboard matching the other buildings of the period. (Photograph by Sally Sims Stokes, 2003.)

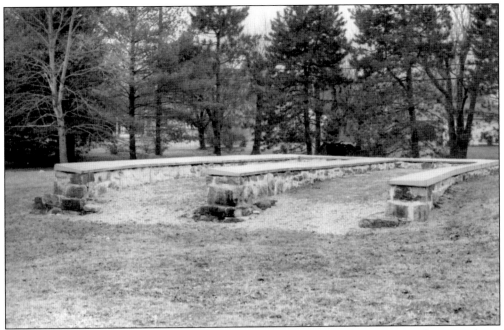

These foundations are all that remains of the large one-story wooden structure that served as a corncrib. It was destroyed in an arson fire in 1988. The ashlar stone *E*-shaped foundation walls have been capped with the hope of being used for a future reconstruction. (Photograph by Sally Sims Stokes, 2003.)

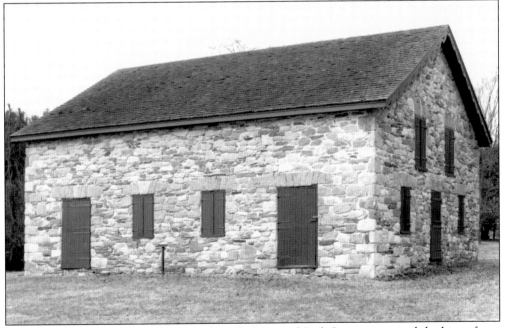

The mule barn was in great disrepair when the National Park Service acquired the home farm, and it underwent extensive restoration in the 1980s. It is one of the only extant buildings where the story of the work animal can be visualized and interpreted. (Photograph by Sally Sims Stokes, 2003.)

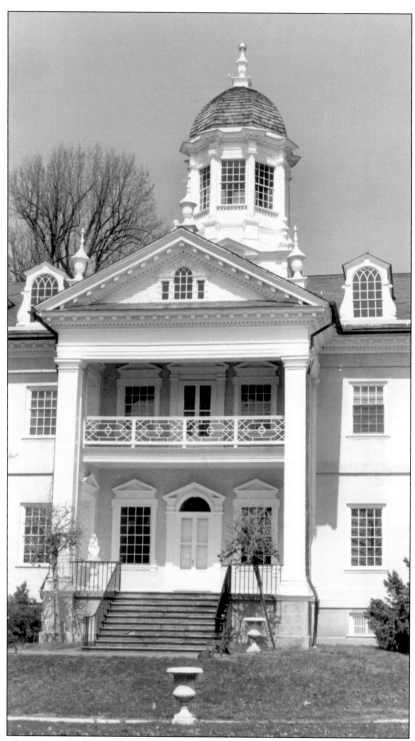

This detail photograph highlights the central portico on the southern facade of the mansion. It is truly an architectural wonder. Come visit and enjoy a walk back in history! (Photograph by Sally Sims Stokes, 2003.)

REFERENCES

Archives Collection, Hampton National Historic Site/National Park Service. Towson, Maryland.

Hastings, Lynne Dakin. *A Guidebook to Hampton National Historic Site*. Towson, MD: Historic Hampton, Inc., 1986.

McKee, Ann Milkovich. *Hampton National Historic Site*. National Register of Historic Places documentation. Hampton National Historic Site, Towson, MD, 2005.

National Park Service Philadelphia Support Office and Hampton National Historic Site. "Hampton NHS Cultural Landscape Report, Part 1" (draft, September 2002).

———. "Hampton NHS Cultural Landscape Report, Part 2" (draft, March 2001).

Peterson, Charles E., FAIA. *Notes on Hampton Mansion*. 2nd ed. Revised and edited by Sally Sims Stokes. College Park, MD: National Trust for Historic Preservation Library Collection of the University of Maryland Libraries, 2000.

Rodney, Marguerite. *Hampton National Historic Site*. Preliminary documentation for the National Register of Historic Places. Hampton National Historic Site, Towson, MD, 1998.

Vlach, John Michael. *Back of the Big House: The Architecture of Plantation Slavery*. Chapel Hill: The University of North Carolina Press, 1993.

DISCOVER THOUSANDS OF LOCAL HISTORY BOOKS FEATURING MILLIONS OF VINTAGE IMAGES

Arcadia Publishing, the leading local history publisher in the United States, is committed to making history accessible and meaningful through publishing books that celebrate and preserve the heritage of America's people and places.

Find more books like this at
www.arcadiapublishing.com

Search for your hometown history, your old stomping grounds, and even your favorite sports team.

Consistent with our mission to preserve history on a local level, this book was printed in South Carolina on American-made paper and manufactured entirely in the United States. Products carrying the accredited Forest Stewardship Council (FSC) label are printed on 100 percent FSC-certified paper.

MADE IN THE USA